# PAUL KLEE

# 1879-1940

IN THE COLLECTION OF

THE SOLOMON R. GUGGENHEIM MUSEUM, NEW YORK

This project is supported by a grant from the
National Endowment for the Arts in Washington, D.C.,
a Federal Agency

Published by The Solomon R. Guggenheim Foundation, New York, 1977

ISBN: 0-89207-006-4

Library of Congress Card Catalogue Number: 77-78148

© The Solomon R. Guggenheim Foundation, 1977

Printed in the United States

# Klee at the Guggenheim Museum

The strength of the Guggenheim's Paul Klee collection lies in its continuity. There are, to be sure, more than a few oils, watercolors, drawings and prints of such exceptional importance that no Klee survey based upon the criterion of quality could easily do without them. But neither are there Klee collections in America that possess a sequential representation as rich and as nearly comprehensive as demonstrated by this exhibition and the accompanying catalogue.

The sixty-seven works recorded and illustrated here are the finest examples in the Guggenheim Collection. The earliest acquisitions were made in 1937, the year of the Guggenheim Foundation's inception, the latest in this current year of 1977. All the media that Klee employed are represented: sixteen oils, twenty-six watercolors and gouaches, fifteen drawings and ten prints. They span the entire creative life of the artist, from three rare sheets of his notebook drawn at the age of fifteen to a gouache executed by the sixty year old artist in the year of his death. Despite some gaps in its chronological sequence, the Guggenheim's Klee collection may be seen as a representative sampling of Klee's rich and marvelous oeuvre.

The selected works are presented for a first showing at the Guggenheim Museum, and all but the few examples that must be withdrawn because of their fragility will continue on a continental tour. Participating institutions are the Musée d'Art Contemporain, Montreal, Musée de Québec, Milwaukee Art Center, University Art Museum, University of California at Berkeley and The Cleveland Museum of Art. The preparatory work for this exhibition was carried out within a framework of Bicentennial celebrations. It was importantly aided by a grant from the National Endowment for the Arts in Washington, D.C., a Federal Agency.

This publication was prepared by Dr. Louise Averill Svendsen who engaged in and supervised the extensive research the project entailed and wrote the introductory essay, *Notes on Klee*. Upon Dr. Svendsen's request, I added the brief biographical and critical texts that subdivide the illustrations. Dr. Svendsen was aided by colleagues within and outside the Guggenheim Museum whose valuable contributions are herewith acknowledged in her name as well as on behalf of the Museum.

Specifically we are deeply indebted to Dr. Jürgen Glaesemer, Curator of the Klee *Stiftung*, Kunstmuseum Bern. Without his advice and generous sharing of scholarly knowledge, many of the problems inherent in this material would never have been clarified. Special thanks are also due to Frau Dr. Katalin von Walterskirchen of the Kunstmuseum Bern, who first introduced Dr. Svendsen to the *Stiftung's* indispensable documentation. Particular gratitude is due to Angelica Zander Rudenstine, Research Curator of the Guggenheim Museum, for her detailed research on the Klee oils in the Collection, which she has published in her monumental *The Guggenheim Museum Collection: Paintings 1880-1945*, 1976. Acknowledgement is made to Linda Konheim, Curatorial Administrator of the Guggenheim Museum, who did the basic research on Karl Nierendorf, of which much is incorporated here. Various other members of the Guggenheim staff are to be thanked for their cooperation, most particularly Karen Lee, Curatorial Coordinator, who assisted with skill and enthusiasm on every facet of this project, and Carol Fuerstein, who edited the manuscript and saw it through the presses.

THOMAS M. MESSER, *Director*
The Solomon R. Guggenheim Museum

# Notes on Klee

*Louise Averill Svendsen*

The first Klees to enter the Guggenheim Museum Collection were those bought directly from the artist. The earliest known purchase, *Tropical Gardening, 1923,* was acquired by Solomon R. Guggenheim, the Museum's founder, and given to the Museum in 1937, the very year the Museum was established. In 1938, the Museum's first director, Baroness Hilla von Rebay, purchased three works from the artist, *Fruitfulness, Pomona Growing Up* and *Peach Harvest,* all painted the previous year. She also acquired from Klee, probably in 1938 as well, the small watercolor, *Park Near B., 1938.* Whether this was obtained by gift or purchase is unclear. Klee inscribed it in gratitude: *"für Hilla Rebay—in Freundschaft"* [for Hilla Rebay—in friendship]. This was acquired by the Museum in the settlement of Miss Rebay's estate in 1971.

Another group of Klee watercolors was obtained indirectly from the artist during the 1930's through the painter Rudolf Bauer, long a close friend and advisor to Miss Rebay. Among these works are *Tree Culture, 1924, Owl Comedy, 1926,* and *Dance You Monster to My Soft Song!,* 1922. (The latter belonged to the St. Annen Museum in Lübeck, Germany, before it was sold by the German government as "degenerate" art.)

The largest group of Klees to enter the Collection came through the purchase by the Foundation of the Nierendorf Estate in 1948. A German art dealer who fled Nazi Germany in 1936, Karl Nierendorf showed the works of exiled German Expressionists in his gallery on 57th Street in New York. He became the particular champion of Klee. We have records of more than a dozen exhibitions of Klee's work held by Nierendorf during the decade 1937-47. And he kept Klee's name before Americans through the publication of books, including an elaborately illustrated monograph on Klee in English which he wrote, and Klee's own *Pedagogical Sketchbook,* reproductions and silkscreen prints (of unusually fine quality), as well as by contributions to exhibitions outside New York. When Nierendorf died intestate in October 1947, the Foundation acquired his entire estate of some 730 objects, of which 121 were by Klee.

In candor, it cannot be said that all of the Nierendorf works were of equal quality. Although they included the much-loved *Red Balloon* of 1922, the superb oil of 1930, *Open Book,* and such watercolors as *Aging Venus,* 1922, and *Singer of Comic Opera,* 1923, to mention a few, there were two fakes, duplicate prints and a vast quantity of reproductions. There were also a number of rather tentative watercolors and drawings which were later traded by the Museum for more important and representative works. The duplicates and reproductions were sold, and the proceeds were used to purchase more Klee graphics, particularly the rare *Inventions* of 1903-05. *Perseus,* 1904, and the *Aged Phoenix,* 1905, were acquired in this way.

The acquisitions of the 1960's and 1970's have been by purchase and by gift. Outstanding among these are a remarkable early oil, *Night Feast,* 1921, from the Bürgi Collection; the outstanding *Barbarian Sacrifice,* 1932, from the Schang Collection; and two important abstract oils, *In the Current Six Thresholds,* 1929, and *New Harmony,* 1936. An amusing drawing of 1927, *Fleeing Ghosts (Spooks),* was given to the Museum by Katharine Kuh in 1975. *Hat, Lady and Little Table,* of 1932, a major oil purchase in 1977, is the Guggenheim's most recent acquisition of Klee's work.

Considering the importance of the Guggenheim's Klee holdings, it is unfortunate that we know comparatively little about the circumstances surrounding the acquisition of so many of the works. The Archives of the Museum provide few records to indicate Klee's relationship to Solomon R. Guggenheim and Miss Rebay. We know from a 1936 catalogue of Mr. Guggenheim's collection[1] that he owned three watercolors of the 1920's at this time. A later publication tells us that Miss Rebay had augmented this number to fifteen by 1939.[2] We have, however, found indications of only two direct communications between Klee and Miss Rebay. One piece of evidence is a carbon of a letter from the Baroness, dated July 28, 1930, in which she informs Klee that 500 German marks are being sent to him for the purchase of *Inscription,* 1926.[3] The other is a bill[4] signed by Klee and dated July 1938 for 3900 Swiss francs for the purchase of *Pomona Growing Up, Peach Harvest* and *Fruitfulness,* all of 1937.

How well Miss Rebay knew Klee is a matter of conjecture. Certainly, as a German-born artist who exhibited at *Der Sturm* in Berlin as early as 1917, she must have been well aware of the reputation of the older artist. That Klee and Miss Rebay had met, we know from the recollections of Nina Kandinsky, the widow of Vasily Kandinsky.[5] Mrs. Kandinsky remembers very clearly one

1. Carolina Art Association, Gibbes Memorial Art Gallery, Charleston, South Carolina, *Solomon R. Guggenheim Collection of Non-Objective Paintings,* March 1-April 12, 1936.
2. Recorded in *Art of Tomorrow,* catalogue for the inaugural exhibition of The Solomon R. Guggenheim Museum at 24 East 57th Street, New York City, on June 1, 1939.
3. This watercolor was purchased for Miss Rebay's private collection and passed into the Museum's Collection in 1941.
4. This bill is among the papers of The Hilla von Rebay Foundation Archives, now on deposit at The Solomon R. Guggenheim Museum.
5. In conversation with Angelica Zander Rudenstine, Research Curator of The Solomon R. Guggenheim Museum, May 25, 1976.

day in 1929 when Miss Rebay and Mr. Guggenheim came to the *Bauhaus* in Dessau to visit her husband. As Klee lived next door, they also went to his studio. Later that same day, Klee reported to the Kandinskys that, as the Baroness was looking through a group of works piled up on the floor, he had remarked, "Since I believe you are interested only in abstract art, you will not find anything among my pictures." Miss Rebay's disdain for figurative art and passion for the non-objective were legendary. "Paintings with an Object" were listed separately, unillustrated in the back of her exhibition catalogues of the Collection, with an explanation that they "were collected to present outstanding artists whose works led to non-objectivity." Yet her prejudices never seemed to deter her critical eye, and, as we have seen, she continued to buy Klee's paintings although she rarely exhibited them. Certainly she considered him a friend. On the cover of a book (the catalogue of the A. E. Gallatin Collection, the Museum of Living Art, New York University, 1937) in her library she has written, in her emphatic scrawl, "Some personal *Art History*," and after the names of artists listed within, has inserted capsule designations. Domela is described as "friend in Paris;" Duchamp as "friend also in Paris;" Kandinsky as a "good friend," but she singles out Klee as "old friend." We have no clues as to what Klee's feelings toward her may have been, beyond his dedication on *Park near B.: "für Hilla von Rebay—in Freundschaft* [for Hilla Rebay—in friendship]."

The situation in regard to the relationship between Karl Nierendorf and Klee is equally cloudy. From the time he opened his gallery in Berlin in 1923, Nierendorf championed the cause of German Expressionism, showing Nolde, Heckel, Rohlfs, Schmidt-Rottluf and the masters of the *Bauhaus*, Kandinsky, Feininger and Schlemmer. However, at this time Klee was under contract to Hans Goltz in Munich. Alfred Flechtheim, who had galleries in Düsseldorf and Berlin, took over Goltz's contract with Klee after 1925 and retained it until he was forced to flee Germany in 1934.[6] Thereafter, Kahnweiler became Klee's dealer. We have no idea of what arrangements, if any, Nierendorf made with Klee after he opened his gallery in New York. For reasons not yet clear, almost none of Nierendorf's records—his correspondence, receipts of purchase and sales—of the period of his American residence came to the Museum with the Estate. We have only three small notebooks and a receipt book. Of these, only one is of importance: a listing of works of art in stock dated 1942, recorded by inventory num-

ber. It is possible to determine which of the Guggenheim's Klees were in Nierendorf's possession by 1942 by matching the inventory numbers with any existing labels or numbers on the backs of paintings. Whether Nierendorf purchased these works outright or took them from Klee on consignment is not known. We have only one other indication of possible direct contact between Klee and Nierendorf, beyond the negotiations that must have taken place in regard to the works in this inventory. Although Nierendorf rarely published catalogues of his exhibitions, in February 1940 he produced a checklist of forty-four works for *Paul Klee: An Exhibition in Honor of the Sixtieth Birthday of the Artist*. Here he states, "The entire collection has just been sent from the studio of the artist. Most of the works are being shown for the first time. The group includes numerous works of 1939." From this we may conclude that the usual negotiations for the purchase and/or exhibition of the works must have taken place between the two men, although as yet we have no documents to substantiate this.

Nierendorf's relationship with Hilla Rebay was cordial, perhaps even close.[7] He not only sold a great number of Kandinskys to the Museum, but continually tried to interest her in works of art he felt he could obtain for the Collection. In the Rebay Archives there is a handwritten letter from Nierendorf to the Baroness, dated November 2, 1946,[8] in which he describes some of the events of a six-month trip to Paris, Switzerland and Germany, reports on the visits to mutual friends and artists, exhibitions and his own future plans. He mentions negotiations with the Klee Estate, slyly playing up to her prejudices. "I saw in the studio of the *Nachlass* [Estate] *many* really good Non objective Klees, most inscribed 'not-for-sale' or [his] 'own collection.' He himself treasured these works *extraordinarily*. I hope I can get some of them at least for a Klee show of NON-OBJECTIVE WORKS. I thank you for the commission to buy for 5000 francs and for the trust you have shown in me. It is *very* good that you are satisfied only with the best." Another letter in the Museum Archives, written by Nierendorf from Germany on Christmas 1946, confirms that he was successful in his negotiations. "I will be glad to return to my work there [New York]. I will bring with me very fine Klees and others." These passages shed considerable light on the histories of a number of Klees in the Collection. A surviving Nierendorf catalogue,

6. Will Grohmann, *Kandinsky*, New York, Abrams, 1955, pp. 78-79.

7. When Nierendorf died without any close relatives in this country, Miss Rebay arranged to have him buried in her plot at Greens Farms, Connecticut.

8. Rebay Archives, see fn. 4.

dated October 1947, entitled, *A Comprehensive Exhibition of Works by Paul Klee: From the Estate of the Artist,* lists seventeen works that are now in the Collection. Again, however, what the terms were, we do not know. Apparently, Nierendorf did not spend the 5000 francs for purchases for the Foundation, for the seventeen works mentioned above were in his possession at his death and passed with his Estate into the Collection.

Interesting among the Klees from the Nierendorf Estate are three small early drawings which have never before been exhibited by the Museum. These are sketches of landscapes probably done from nature on some of the many walking trips and outings Klee made during his school days in Bern. The earliest is an ink drawing of *Hilterfingen* (cat. no. 1) dated July 19, 1895. Here Klee records the small houses of the village with the old church in the middle distance, a scene familiar to him from his many visits to his aunt who lived in the neighboring village of Oberhofen on the shore of Lake Thun (Thunersee). The second small ink sketch, *Thunersee near Schadau* (cat. no. 2), dated September 8, 1895, is of Lake Thun itself with the castle of Schadau on its shore. The third landscape is an unfinished, undated pencil drawing entitled *Gemmi Pass, Valais Alps* (cat. no. 3), undoubtedly done during an excursion in the mountains of the Valais.

When these drawings were examined in 1973 by Jürgen Glaesemer, Curator of the Klee *Stiftung* in Bern, he suggested that they may be pages from a missing sketchbook of 1895. The *Stiftung* owns nine Klee sketchbooks[9] dating from 1892 to 1898. These are numbered I through X, but No. V, of 1895, is missing. These sketchbooks are all pocket-sized bound notebooks with linen board covers, each containing about two dozen pages of heavy-weight stock. They all differ slightly in size, the smallest sheet (No. I) is 4⅜ x 6¾″ (11.1 x 17.1 cm.), the largest (No. X) is 6½ x 9¼″ (16.6 x 23.5 cm.). The three Guggenheim sheets appear to be from a notebook slightly smaller than the others (they measure approximately 3⅞ x 6⅝″ [9.9 x 16.8 cm.]), but their uneven vertical edges may indicate that they were clipped from a bound sketchbook and that some of the page was cut away.

We may confirm Glaesemer's supposition that our sheets belong to the missing Sketchbook No. V by means of dating. The drawings in Sketchbook No. IV begin in January of 1894 and continue through February of 1895.[10] Sketchbook No. VI covers the period between September 24, 1895 and March 1896. Two of the Guggenheim's drawings are dated July 19, 1895, and September 8, 1895, respectively, both within the period the missing Sketchbook V would logically have covered. Further, the earlier drawing *Hilterfingen* is inscribed "V. 101;" the later, *Thunersee near Schadau,* "V. 110." Klee gives the finished sketches catalogue numbers throughout the sketchbooks, presaging the elaborate number system he devised to identify the works.[11] Finally, "V. 101" and "V. 110" fall in proper sequence between the numbers assigned in Sketchbooks IV and VI: the last number recorded in Sketchbook No. IV is "V. 98" and the first drawing in Sketchbook No. VI is "V. 202."

Unfortunately, the third Guggenheim drawing, *Gemmi Pass, Valais Alps,* is neither dated nor numbered. However, this pencil sketch can be compared with another pencil drawing of the period, an unfinished landscape in Sketchbook VI, page 8.[12] In each work, Klee has written notes on the face of the drawing to aid him in completing the work at a later time; thus *S* for *Schnee* (snow) on the mountain peaks; *NEBEL* (mist) in the valley; *NAH* (near), *FERN* (far) indicating the relative positions of foreground and middle distance. Such notes are very rare in Klee's early works and do not appear after 1895.

One further consideration for dating this drawing 1895 is to be found in Klee's diaries. In Diary I, he notes "When about fifteen, a student trip with Professor Tobler. I. Bern-Grimselhopsig . . . IV Gemmipass-Kandersteg. . . ."[13] Klee would have been about fifteen in the summer of 1895.

Klee was almost fanatically precise and orderly. As we have seen, he devised an inventory system for his sketchbooks, and even his early childhood drawings are recorded in "*Klee Katalog B 1 1883-1917 Kindzeich*"[14] by inventory number, title, date and medium. Indeed Klee listed all his work according to an elaborate

---

9. Glaesemer has published all the Sketchbooks with extensive descriptions and photographs in Paul Klee, *Handzeichnung I,* Kunstmuseum Bern, 1973, pp. 19-72.

10. The order of the drawings within the Sketchbooks is not strictly chronological and some, as indicated by Klee's dating, were reworked or completed some time after they were begun.

11. The catalogue numbers were not assigned in chronological order. Klee seems to have numbered his sketches only when they were completed. For example, in Sketchbook VI three unfinished sketches are neither numbered nor dated.

12. Reproduced in Glaesemer, *op. cit.,* p. 52, no. 131.

13. *The Diaries of Paul Klee, 1898-1918,* edited by Felix Klee, Berkeley and Los Angeles, University of California Press, 1964, p. 20.

14. Reproduced in Glaesemer, *op. cit.,* p. 7.

system in his *Oeuvrekatalog*.[15] At first there were few entries, but by 1905, thirty-nine works were recorded, and the *Oeuvrekatalog* took on the form which Klee continued to follow throughout his life. Each year was begun with a new page which was ruled in columns for inventory number, title and medium and letter classification. The works were then recorded chronologically beginning with number 1. The medium and the support were described in detail as in "little green oil sketch on Japan paper" or "watercolor and oil transfer drawing on chalk-primed linen gauze, mounted on gouache-painted board." In the case of watercolors, Klee often noted not only the type and color of paper but even the watermark. Until 1914, he categorized each work as "A" or *"ohne Natur"* (fantasies or copies) or "B" *"nach Natur"* (after Nature). After 1914, the letter classification changed to a system of classification by medium: "G" for painting *(Gemälde)*, "A" for watercolor *(Aquarell)* and "Z" for drawing *(Zeichnungen)*. Beginning in 1931, these descriptions were changed to *Tafel* for painting, *farbige Blätter* (colored sheets) for watercolors and *zeichnung (zeichenblätter)* (drawings)/*schwarze Blätter* (black sheets)/*nicht-farbige Blätter* (non-colored sheets) for drawings. The pages of the catalogue were then ruled with the media headings at the top, and the titles were entered chronologically under the proper headings. By 1932 watercolors were called *mehrfarbige Blätter* (many colored sheets) and drawings *einfarbige Blätter* (single colored sheets). Such a simplified classification system provided more adequately for Klee's often complicated experimental techniques.

As the demand for Klee's works grew, he invented an elaborate auxiliary numbering system. In the *Oeuvrekatalog,* he continued to number the works chronologically. But to this first number he added a letter and another number. For example, in 1925, when 250 works were recorded, the first nine works of the year are numbered 1-9, and 10 is followed by the letters K-o (null), 11, K-1 and so on to 19, which is followed by K-9. At 20 the letter changes to l and the next ten numbers are l-o to l-9. The numbers following the letters run in tens, but the alphabetical order is not strictly kept. The sequence in 1925 is K, l, m, n, v, p, q, R, S, A, B, C, d, e, f, g, H, J, T, u, V, W, X, Y, Z.

The reason for this intricate system is given by Felix Klee;[16] "This was done at the request of art dealers who did not want buyers to know how many works Klee produced in a year." Their request seems reasonable, as Klee's average yearly production was between 250-300 works. (When he died, he had recorded nearly 9000 works.) Although Klee signed and dated his works and inscribed them with title, letter and number, after 1924 the chronological number was not included and can be found only in the *Oeuvrekatalog.*

Klee devised one other classification system for his own and his dealers' use. He inscribed a few of the works in pencil with *S.cl.* or *Sond. Cl.,* meaning *Sonderklasse* or "special class," which was an indication of price and quality. Pencilled Roman numerals were sometimes employed to indicate quality: before the mid-1920's, Klee used the numbers I-III, with III signifying the price. The Guggenheim Collection Klees, starting with those of 1924, include works marked from I to VIII, indicating a change to another numbering code, the precise meaning of which is at present uncertain.

Although this volume has not been conceived as a detailed catalogue raisonné, in the interest of scholarly exactitude, each work of art has been checked in Klee's *Oeuvrekatalog* at the Klee *Stiftung* and Klee's inventory number and descriptions, including abbreviations and his own idiosyncratic spellings,[17] have been transcribed exactly. Klee's entry follows the abbreviation OK *(Oeuvrekatalog)* and is italicized. The Guggenheim Museum acquisition number follows thereafter. The first two digits of this number indicate the year of acquisition, the digits following the decimal point indicate where the work falls in the total chronology of the Foundation acquisitions. Thus number 37.509 came into the Collection in 1937 and was the Foundation's 509th acquisition. The next line, medium and dimensions, translates as closely as possible Klee's descriptions, modified only to conform with modern registration practices. Signature, date and inscriptions on the works are transcribed as they appear or are known to have appeared. In one or two cases, the signatures can be recaptured only under ultraviolet light or are known from early photographs. If no inscriptions are listed for works on paper they have been cut away and lost. (This was sometimes done, unfortunately, to make a watercolor fit into an existing frame.) Finally, the complete provenance, or as much of it as is known at present, is listed.

15. Klee's *Oeuvrekatalog* is discussed in Glaesemer, *op. cit.,* pp. 6-8, 20-21 and in the foreword of his *Paul Klee, Die farbigen Werke im Kunstmuseum Bern, Katalog der Gemälde, farbigen Blätter, Hinterglasbilder und Plastiken,* Bern, Kornfeld und Cie., 1976.

16. Felix Klee, *Paul Klee, His Life and Work in Documents,* New York, Braziller, 1962, Appendix II, pp. 201-203.

17. Klee, for example, retained the use of "C" (as in *Carton*) even though accepted German practice early in the century had changed to "K" *(Karton)*.

# Chronology

**1879**
December 18, born in Münchenbuchsee, near Bern, to Hans Klee (1849-1940), a music teacher, and Ida Maria Frick Klee (1855-1921).

**1880**
Family moves to Bern.

**1886-1898**
Primary and preparatory schools in Bern. 1898, graduates from *Literargymnasium,* Bern.

**1898-1901**
To Munich. October, begins studies with Heinrich Knirr; at Academy with Franz von Stuck.

**1901-1902**
October to May, travels in Italy with sculptor, Hermann Haller; visits Milan, Genoa, Pisa, Rome, Naples and Florence. May 2, returns to Bern.

**1902-1906**
Lives in parents' house in Bern.

**1903**
Makes first etchings.

**1905**
April to June 13, visits Paris. Begins glass paintings.

**1906**
Exhibits in Munich *Secession.* Marries Lily Stumpf. October, moves to Munich.

**1907**
November 30, son Felix is born.

**1911**
First one-man show at Moderne Galerie (Thannhauser), Munich. Meets Kubin, Kandinsky, Jawlensky, Arp, Macke, Marc, Campendonk and Münter. Joins *Blaue Reiter* group.

**1912**
Participates in second *Blaue Reiter* exhibition. April 2 to 18, second trip to Paris; there meets Delaunay, Kahnweiler, Uhde. Translates Delaunay's essay "On Light" for *Der Sturm* magazine, Berlin.

**1913**
Exhibits in *Erster Deutscher Herbstsalon,* Berlin.

**1914**
April 5 to 22, visits Tunis and Kairouan with Louis Moilliet and August Macke. Begins to work primarily in watercolor.

**1916-1918**
Service in the German Army.

**1920**
Exhibits 362 works at Galerie Hans Goltz, Munich. *Schöpferische Kon-*
*fession [Creative Credo]* published by E. Reiss, Berlin. November 25, appointed to faculty of *Bauhaus,* Weimar.

**1921**
Moves to Weimar.

**1923**
*Wege des Naturstudiums [Ways of Studying Nature]* published in Bauhausbücher series. Vacation on island of Baltrum.

**1924**
First exhibition in America, Société Anonyme, New York. Founding of *Blaue Vier:* Kandinsky, Klee, Feininger, Jawlensky. Summer vacation in Sicily. Weimar *Bauhaus* closes in December.

**1925**
*Bauhaus* moves to Dessau. *Pädagogische Skizzenbuch [Pedagogical Sketchbook]* published in Bauhausbücher series. Participates in first group exhibition of Surrealists, Paris. First one-man show in Paris, Galerie Vavin-Raspail.

**1926**
Summer in Italy. August, moves to Dessau.

**1928**
Summer in Brittany. December 17, 1928 to January 17, 1929, visits Egypt.

**1929**
For fiftieth birthday, one-man exhibition at Galerie Flechtheim, Berlin.

**1930**
Exhibition at The Museum of Modern Art, New York.

**1931**
Resigns from *Bauhaus,* April 1, appointed professor at Academy in Düsseldorf.

**1933**
Dismissed from Academy by Nazi regime. December, moves to Bern.

**1935**
Large exhibitions in Bern, Basel and Lucerne. Onset of fatal illness.

**1937**
Visited by Picasso, Braque and Kirchner in Bern. 17 works shown in Nazi exhibition of "Degenerate Art" in Munich. 102 works confiscated by Nazis from public collections in Germany.

**1938**
Exhibitions at Buchholz (Curt Valentin) and Nierendorf Galleries, New York, and Galerie Simon (Kahnweiler), Galerie Balaÿ et Carré in Paris.

**1940**
February, major exhibition of works of 1935-1940 at Kunsthaus Zürich. June 29, dies at Muralto-Locarno.

# Works in the Exhibition

The selection begins with ink and pencil sketches executed before the turn of the century. In view of Paul Klee's birth at the end of 1879, these must be considered juvenilia—interesting historically but not yet revealing the attributes of the artist's mature style. Even the splendid sequence of early etchings that the youthful Klee completed between 1903 and 1905 enchant us more today than they appear to have satisfied the artist who, shortly before their creation, complained in his journals: "... I am again all on the side of satire. Am I to be completely absorbed by it once more? For the time being it is my only creed. Perhaps I shall never become positive?"

1

*Hilterfingen.* July 19, 1895
Page from a Sketchbook, probably Sketchbook
No. V, 1895

Not in OK

48.1172 x 493

Ink on paper, 3¾ x 6⅜″ (9.5 x 16.9 cm.)

Inscribed u.l.: *Hilterfingen // Den 19. VII. 95. //*
*Stunden:* $\frac{11\frac{1}{2} \cdot I}{3\frac{1}{2}}$; l.l.: *V. 101 Paul Klee // 19. VII.*

*95*; l. of u.c.: *n f*; u.r.: *IV*

PROVENANCE:
Karl Nierendorf, New York, by 1947
Acquired with the Estate of Karl Nierendorf, 1948

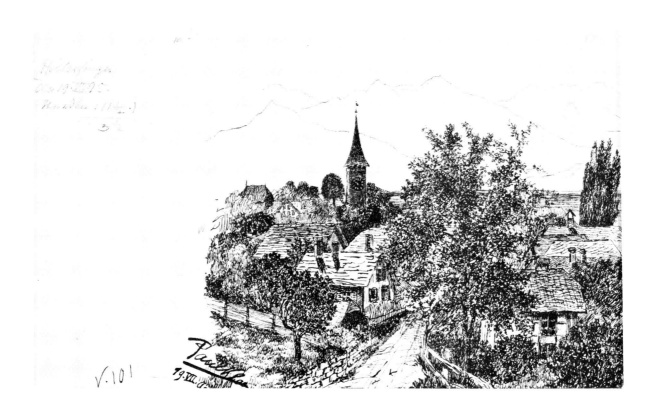

2

*Thunersee near Schadau.* September 8, 1895
*(Thunersee bei Schadau)*

Page from a Sketchbook, probably Sketchbook
No. V, 1895

Not in OK

48.1172 x 537

Ink on paper, 3 ⅞ x 6 ⅝″ (9.9 x 16.8 cm.)

Inscribed u.l.: *N. F.*; l.l.: *Thunersee bei Schadau
V.110*; u.r.: *XII.*; signed and dated l.r.: *Paul Klee //
81 x .95*

PROVENANCE:
Karl Nierendorf, New York, by 1947
Acquired with the Estate of Karl Nierendorf, 1948

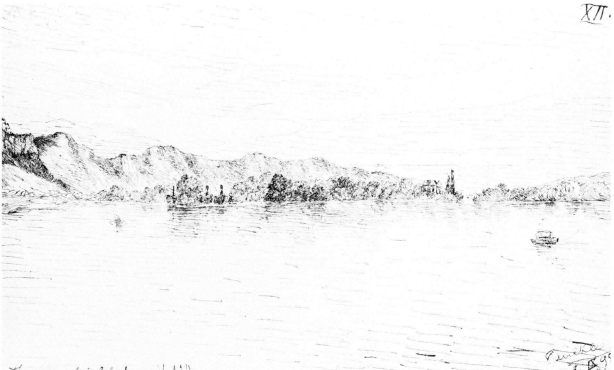

**3**

*Gemmi Pass, Valais Alps.* c. 1895
*(Gemmi Passhöhe, Walliseralpen)*
Page from a Sketchbook, probably Sketchbook
No. V, 1895

Not in OK

48.1172 x 536

Pencil on paper, 3 ⅞ x 6 ⅝″ (9.9 x 16.8 cm.)

Inscribed u.l.: *Gemmi Passhöhe // Walliseralpen;*
within drawing, l. to r.: *M    F    NAH    FERN*
*NEBEL    M    S*

PROVENANCE:
Karl Nierendorf, New York, by 1947
Acquired with the Estate of Karl Nierendorf, 1948

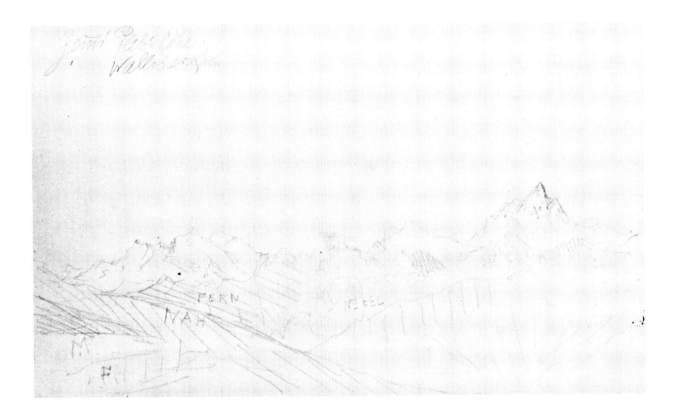

**4**

*Virgin in a Tree (Invention 3).* July 1903
*(Jungfrau [Träumend])*

OK    *1903, 2 (A) Jungfrau im Baum Radierung*
*(geätzt) auf Zink*

Kornfeld no. 4a

48.1172 x 365.2

Etching on white wove paper: plate, 9⅜ x 11¾″
(23.8 x 29.9 cm.); sheet, 12½ x 16⅝″
(31.8 x 42.4 cm.)

Inscribed on plate l.c.: *Jungfrau (träumend) // Bern*
*Juli 03 // P.K.*; signed in pencil l.r.: *Paul Klee*

**5**

*Two Gentlemen Bowing to One Another, Each*
*Supposing the Other to be in a Higher Position*
*(Invention 6).* September 1903
*(Zwei Männer, einander in höherer Stellung*
*vermutend, begegnen sich)*

OK    1903, 5 *(A) Zwei Männer, einander in höherer*
*Stellung vermutend, begegnen sich Radierung auf*
*Zink geätzt*

Kornfeld No. 7 I

48.1172 x 365.1

Etching on white wove paper: plate and sheet,
4⅝ x 8⅛″ (11.8 x 20.7 cm.)

Inscribed on plate l.l.: *P.K. // Bern Sept. .03.*; l.r.:
*6.Inv.6*

**6**

*Comedian (Invention 4).* March 1904
*(Komiker)*

OK    *1904, 14 (A) Komiker II Fassung auf Zink,*
*geätzt*

Kornfeld 10 IIa

48.1172 x 365.3

Etching on white wove paper: plate, 5 ⅞ x 6 ⅜″
(15 x 16.2 cm.); sheet, 6 ¼ x 6 ¾″ (15.9 x 17.2 cm.)

Inscribed on plate l.c.: *Komiker. (Inv. 4.);* l.r.: *P.K.*
*Bern 04 // März*; signed in pencil l.r.: *Paul Klee*

**7**

*Perseus (Wit has Triumphed over Sadness)*
*(Invention 8)*. December 1904
*(Perseus [Der Witz hat über das Leid gesiegt])*

OK    *1904, 12 (A) Der Witz hat über das Leid*
*gesiegt Radierung auf Zink geätzt*

Kornfeld no. 15a

73.2040

Etching on white wove paper: plate, 5 x 5⅝″
(12.8 x 14.3 cm.); sheet, 11 x 12½″ (27.9 x 31.8 cm.)

Inscribed on plate l.l.: *Perseus (der Witz hat über*
*das Leid gesiegt.)*; l.r.: *PK Bern // Dez 04 // Inv. 8.*

**8**

*Aged Phoenix (Invention 9).* 1905
*(Greiser Phönix)*

OK    *1905, 36 (A) Greiser Phoenix Radierung auf
Zink, geätzt*

Kornfeld no. 17IIb

75.2203

Etching on white wove paper: plate, 10¾ x 7¾"
(27.1 x 19.8 cm.); sheet, 13⅜ x 9¾" (34 x 24.8 cm.)

Inscribed on plate l.r.: *Greiser Phönix (Inv. 9.) //
P.K. Bern // März 05*; inscribed in pencil l.l.: *2/30*;
l.r: *Klee 1905/36*

Full self-confidence as an artist comes to Klee only after persistent efforts to comprehend and control color. Matisse's work, which he had first seen at Thannhauser's Moderne Galerie in Munich in 1909, and a seventeen-day trip to Tunisia taken much later, in 1914, during which he became aware of the exquisite colors of the region, are among the factors that contribute to Klee's final resolution of the troublesome color element. No longer diffident now, he writes in his diary: "Color possesses me. I don't have to pursue it. It will possess me always, I know it. That is the meaning of this happy hour: Color and I are one. I am a painter."

One of the few gaps in the Guggenheim's Klee collection is due to the absense of watercolors inspired by the artist's North African journey. But the still tense *Flowerbed,* 1913, and the tenderly structured *Bavarian Don Giovanni,* 1919, are most persuasive personal statements. The latter of these two examples benefited from a long period of diligent concentration that Klee was able to devote to his art while serving, none too enthusiastically, in the German army during World War I.

9

*Flowerbed.* 1913
*(Blumenbeet; Flower Garden)*

OK   *1913, 193 (A) Blumenbeet Öl, auf Pappe*

48.1172 x 109

Oil on board, 11⅛ x 13¼″ (28.2 x 33.7 cm.)

Signed and inscribed u.l.: *Klee // 1913 193*

PROVENANCE:
Purchased from the artist by Hans Goltz, Munich, June-July 1918
Karl Nierendorf, New York, by 1947
Acquired with the Estate of Karl Nierendorf, 1948

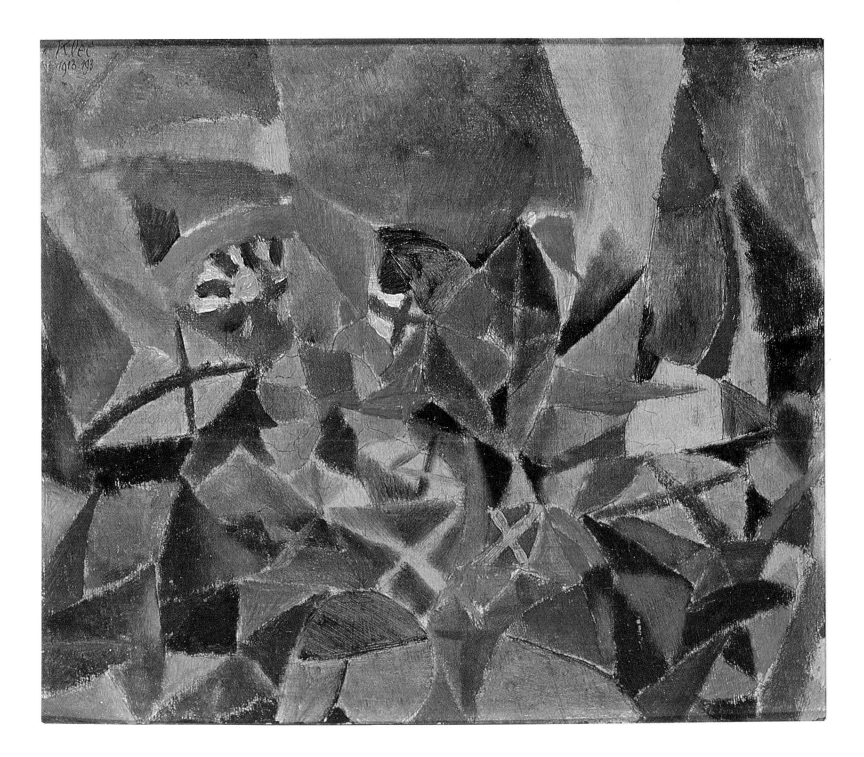

*Garden of Passion.* 1913
*(Garten der Leidenschaft)*

OK   *1913, 155 (A) Der Garten der Leidenschaft*
*Zinkgeätzt*

Kornfeld no. 56e

48.1172 x 365.7

Etching on white wove paper: plate, 3⅝ x 5½″
(9.2 x 14 cm.); sheet, 9⅛ x 11¾″ (23.2 x 29.8 cm.)

Inscribed in pencil l.l.: *Garten der Leidenschaft;*
signed l.r.: *Klee*

**11**

*Little Cosmos.* 1914
*(Kleinwelt)*

OK    *1914, 120 Kleinwelt, in Zink geätzt Radierung*
*Kisling*

Kornfeld no. 61Bb

48.1172 x 365.9

Etching on yellow wove paper: plate, 5⅝ x 3⅞″
(14.4 x 9.6 cm.); sheet, 16½ x 12⅝″ (41.9 x 32.1 cm.)

Inscribed in pencil l.l.: *Kleinwelt*; signed l.r.: *Klee*

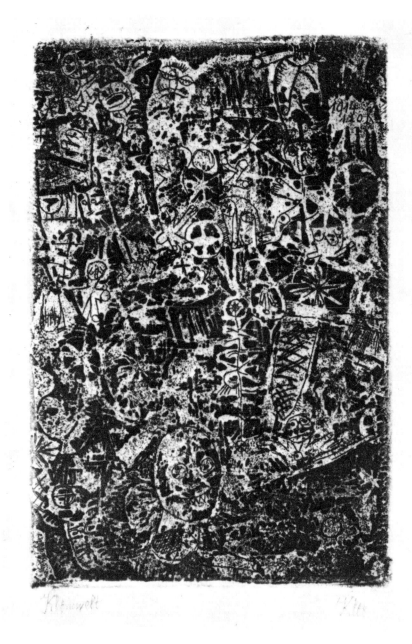

*The Idea of Firs.* 1917
*(Die Idee der Tannen)*

OK    *1917, 49 Die Idee der Tannen Aquarell mit
Ingres Verkauft Goltz Juli 20*

74.2101

Watercolor on paper mounted on board: paper
support, 9½ x 6⅜″ (24 x 16 cm.); board mount,
12⅜ x 9⅛″ (31.4 x 23.4 cm.)

Signed on support u.r.: *Klee*; inscribed on mount
l.l.: *1917-49*

PROVENANCE:
Purchased from the artist by Hans Goltz, Munich,
July 1920
Heinrich Stinnes, Cologne
J. B. Neumann, New York
Purchased from Neumann by Charmion von
Wiegand
Purchased from von Wiegand by Eve Clendenin,
New York, 1955
Bequest of Eve Clendenin, 1974

13

*The Bavarian Don Giovanni.* 1919
*(Der bayrische Don Giovanni)*

OK    *1919, 116 Der bayrische Don Giovanni
Aquarell Zeichenpapier (A) verkauft Goltz April 20*

48.1172 x 69

Watercolor on paper, 8⅞ x 8⅜″ (22.5 x 21.3 cm.)

Signed u.r.: *Klee;* inscribed within picture: *Emma
Kathi Mari Cenzl Thères*

PROVENANCE:
Purchased from the artist by Hans Goltz, Munich,
April 1920
Purchased from the artist's estate by Karl Nieren-
dorf, New York, 1947
Acquired with the Estate of Karl Nierendorf, 1948

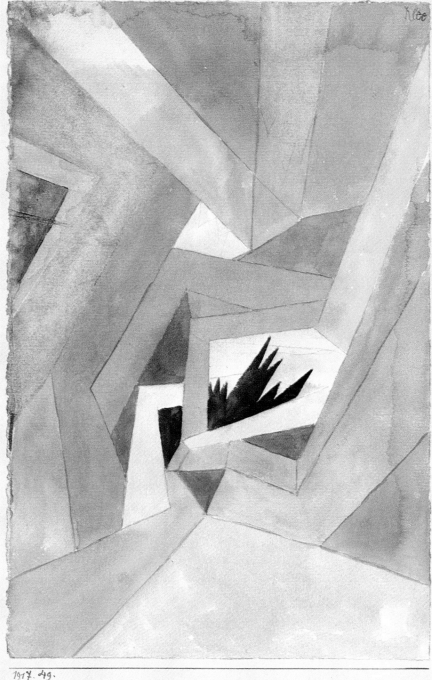

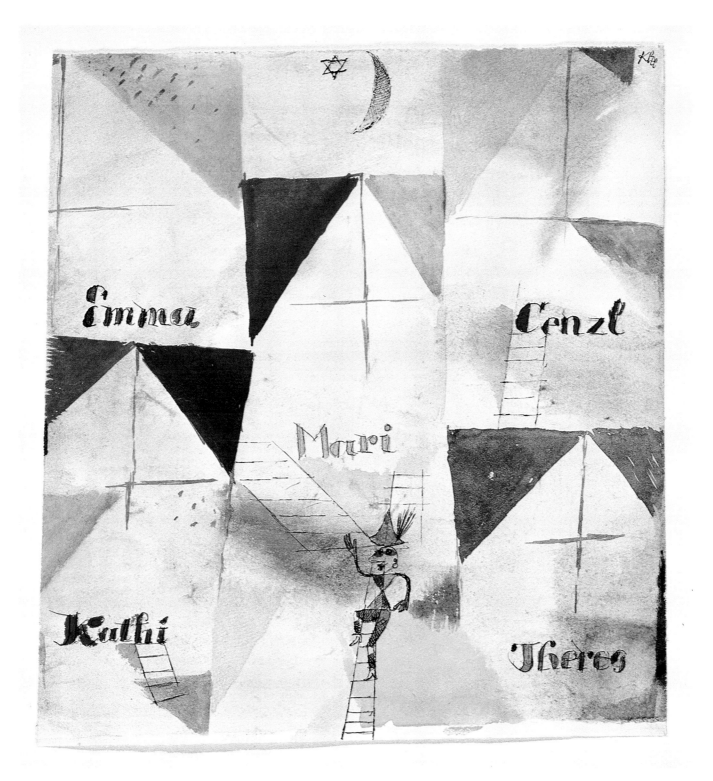

The Bauhaus phase that begins for Klee in 1920 is characterized by a deliberate concern with formal structure. Not unlike his old friend and Bauhaus colleague, Vasily Kandinsky, Klee strives to create a formal "grammar" that would be firm and dependable enough to support his ever surging intuition. But unlike Kandinsky, Klee is not much concerned about the presence or absence of subject matter *(Gegenstand)* and therefore works often in both abstract and figurative modes without deliberately distinguishing between them. These modes merge with and become part of a vocabulary that contains geometric as well as free organic imagery. In such early Bauhaus gems as *Red Balloon,* 1922, Klee achieves weighty results with slight means. Through a bare suggestion of subject matter he creates fullness of associations; through formal concentration, monumentality; through fragile texture, a sense of permanence; through geometric reduction, richness of expression; and through uninhibited release of fantasy, an acute sense of reality.

**14**

*Before the Festivity.* 1920
*(Vor dem Fest)*

OK    *1920, 177 Vor dem Fest Ölfarbezeichn. und*
*Aquarell Italien Ingres gelbl.-grün*

48.1172 x 68

Watercolor and oil transfer drawing on paper
mounted on board: paper support, 12¼ x 9⅜″
(31.1 x 23.7 cm.); board mount, 14¾ x 12⅞″
(37.6 x 32.8 cm.)

Signed on support u.l.: *Klee;* inscribed on mount l.l.:
*1920/177 Vor dem Fest*

PROVENANCE:
Purchased from the artist's estate by Karl Nieren-
dorf, New York, 1947
Acquired with the Estate of Karl Nierendorf, 1948

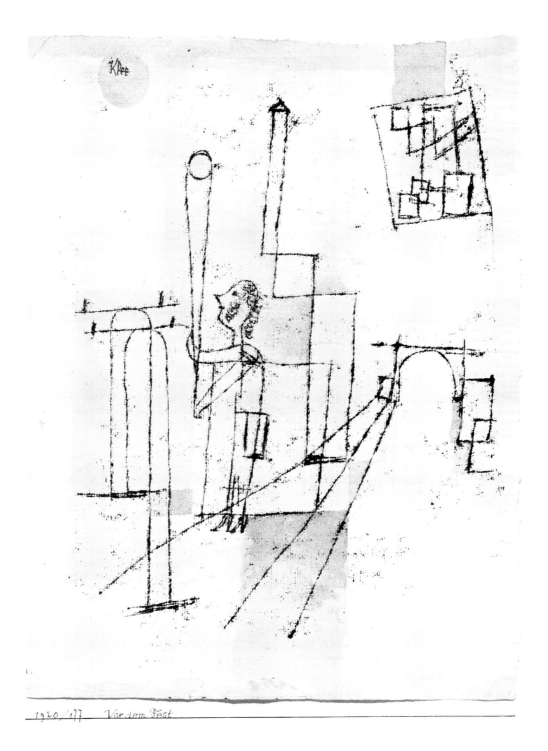

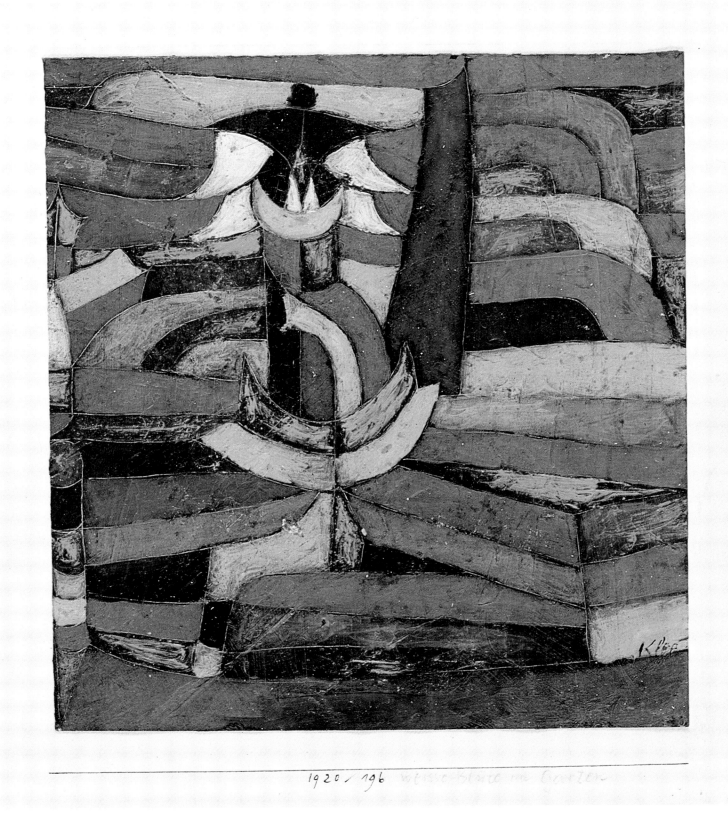

1920/196 Weisse Blüte im Garten

15

*White Blossom in Garden.* 1920
*(Weisse Blüte im Garten)*

OK    *1920, 196 Gartenbild kl. grüne Ölskizze
Japanpapier (G)*

48.1172 × 157

Oil on paper mounted on paper: paper support,
7 × 6¾″ (17.8 × 17.2 cm.); paper mount, 8⅝ × 8⅛″
(22 × 20.7 cm.)

Signed on support l.r.: *Klee;* inscribed on mount l.c.:
*1920/196 Weisse Blüte im Garten*

PROVENANCE:
Karl Nierendorf, New York, by 1947
Acquired with the Estate of Karl Nierendorf, 1948

16

*Runner at the Goal.* 1921
*(Läufer am Ziel)*

OK    *1921, 105 Läufer am Ziel Aquarell Deutsches
Ingres gelbe*

48.1172 × 55

Watercolor and gouache on yellow Ingres paper
mounted on board: paper support with border,
12⅞ × 9⅜″ (32.7 × 23.8 cm.); board mount,
15½ × 12″ (39.3 × 30.3 cm.)

Signed on support c.r.: *Klee;* inscribed on border of
support l.l.: *1921 105 Läufer am Ziel;* on mount l.l.:
*s. cl.*

PROVENANCE:
Purchased from the artist's estate by Karl Nieren-
dorf, New York, 1947
Acquired with the Estate of Karl Nierendorf, 1948

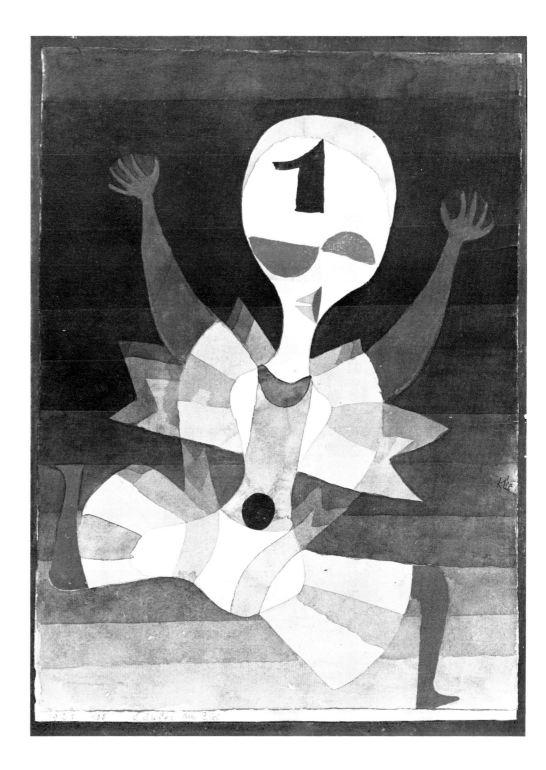

**17**

*Hoffmannesque Scene.* 1921
*(Hoffmanneske Szene)*

OK    *1921, 123 Hoffmanneske Märchenszene Litho*
*1 schwartzer 2 farbiger Steine für die Meistermappe*
*des Bau = /hauses gestiftet. (L)*

Kornfeld no. 82 IIc

73.2029

Color lithograph on white wove paper: image,
12⅜ x 9″ (31.4 x 22.9 cm.); sheet, 14 x 10¼″
(35.5 x 26.1 cm.)

Signed and inscribed in pencil l.c.: *Klee 1921/123*

**18**

*Night Feast.* 1921
*(Nächtliches Fest)*

OK    *1921, 176 Nächtliches Fest Öl Papier*
*aufgeklebt auf Carton aufgezogen später auf Z—*
*Pappe aufgekittet Besitz Frau Bürgi—Bern/1930*

73.2054

Oil on paper mounted on board: paper support,
14½ x 19⅝″ (36.9 x 49.8 cm.); board mount,
19¾ x 23⅝″ (50 x 61 cm.)

Signed and dated l.l.: *Klee 21;* inscribed on reverse
of mount: *1921/176 // "Nächtliches Fest"*
*// Klee // Herrn Rolf Bürgi // bei Dr. Schwarz //*
*Junkerngasse 32 // Bern // 21/176*

PROVENANCE:
Purchased from the artist by Frau Bürgi, Belp-Bern,
Switzerland, 1930
Collection Bürgi, 1930-73
Purchased by Galerie Beyeler, Basel, January 1973
Purchased from Galerie Beyeler, December 1973

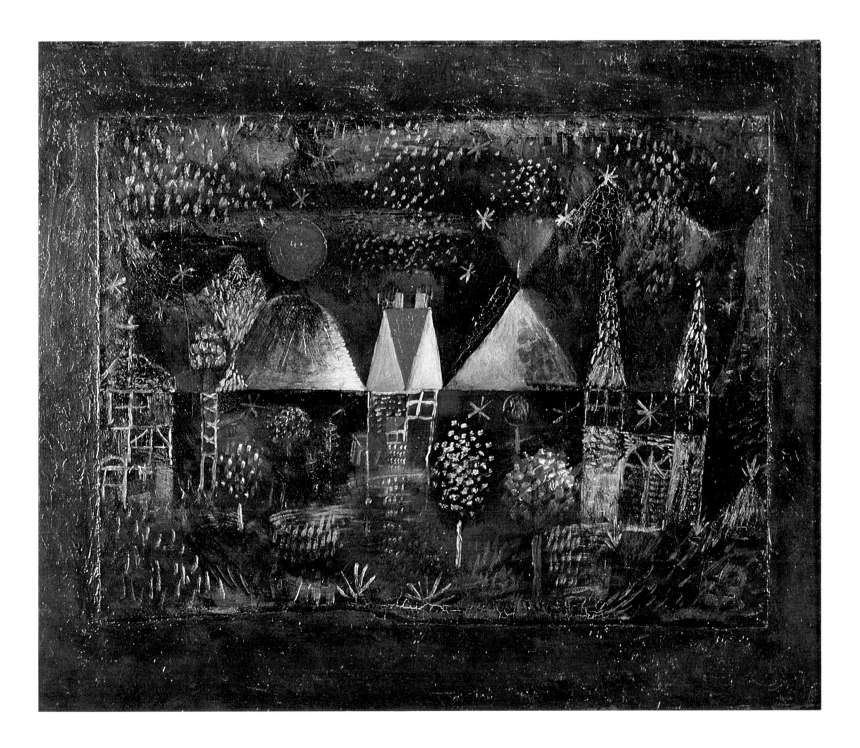

**19**

*From the Song of Songs "Let Him Kiss Me with
the Kisses of His Mouth" (II Version). 1921
(Schriftbild aus dem hohen Lied "Er küsse mich
mit seines Mundes Kuss" [II Fassung])*

OK    *1921, 179 Schriftbild aus dem hohen Lied "Er
küsse mich mit seines Mundes Kuss" (II Fassung)
Feder und Aquarell Briefpapier (A)*

48.1172 x 535
Ink and watercolor on paper, 6⅜ x 7⅞"
(16.2 x 17.5 cm.)

Signed on support l.r.: *Klee;* inscribed within pic-
ture: *E Er Küsse mich // mit seines Mundes Kuss //
Denn Lieblicher // Wie Würzwein ist deine Liebe
lieblich // duften deine Salben // Dein Name ist
// wie ausgegossen Ol // darum lieben dich die
Jungfraun // Ja mit Recht // lieben sie dich;* across
mount l.: *1921/179 (aus dem hohen Lied) (II.
Fassung);* below inscription l.l.: *II*

PROVENANCE:
Karl Nierendorf, New York, by 1947
Acquired with the Estate of Karl Nierendorf, 1948

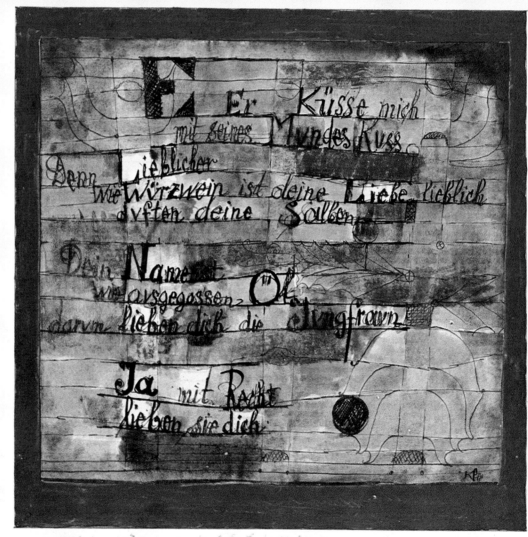

20

*Aging Venus.* 1922
*(Die alternde Venus)*

OK    *1922, 8 Die alternde Venus Aquarell und
Ölfarbezeichnung Kupferdruckpapier (A)*

48.1172 x 63

Watercolor and oil transfer drawing with paper
collage mounted on board: paper support, 11⅝ x
23⅛″ (29.5 x 58.8 cm.); board mount, 13 x 23¼″
(33 x 58.9 cm.)

Signed and dated on support c.r. edge: *Klee//1922;*
inscription on mount l.r. now cut away

PROVENANCE:
Purchased from the artist's estate by Karl Nieren-
dorf, New York, 1947
Acquired with the Estate of Karl Nierendorf, 1948

**21**

*Dance You Monster to My Soft Song! 1922*
*(Tanze Du Ungeheuer zu meinem sanften Lied!)*

OK   *1922, 54 Tanze Du Ungeheuer zu meinem*
*sanften Lied! Aquarell u. Ölfarbezeichnung. Gaze*
*gipsgrundiert (A)*

38.508

Watercolor and oil transfer drawing on plaster-
grounded gauze mounted on gouache-painted paper:
gauze support, ca. 13¾ x 11½″ (35 x 29.2 cm.);
paper mount, 17⅝ x 12⅞″ (44.9 x 32.7 cm.)

Inscribed across bottom of support: *Tanze Du*
*Ungeheüer! Zu meinem sanften Lied;* on mount l.c.:
*1922/54 Tanze Du Ungeheüer zu meinem sanften*
*Lied!*

PROVENANCE:
St. Annen-Museum, Lübeck, 1927-37
Banned by the German government as degenerate
art, 1937
Purchased from Rudolf Bauer by Solomon R.
Guggenheim, 1938
Gift, Solomon R. Guggenheim, 1938

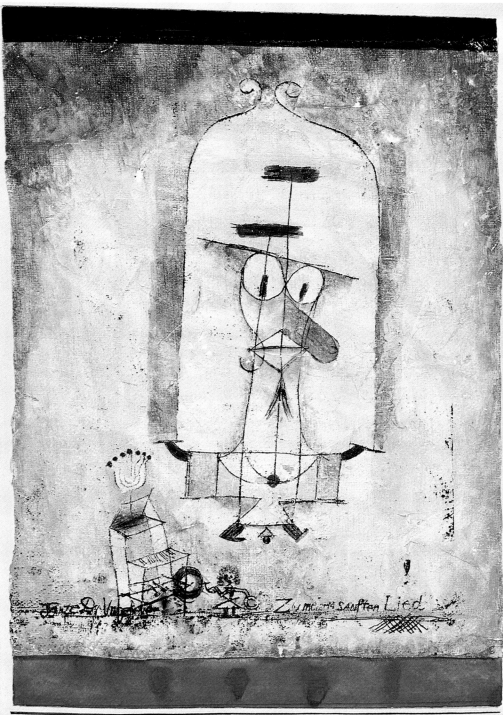

**22**

*Costumed Puppets.* 1922
*(Kostümierte Puppen)*

OK   *1922, 85 Kostümierte Puppen Federzeichnung
Canson-Ingres*

48.1172 x 481

Ink on paper mounted on board: paper support,
9⅜ x 6⅝″ (23.9 x 16.9 cm.); board mount,
12½ x 9⅞″ (17.2 x 25.1 cm.)

Signed on support l.c.: *Klee;* inscribed on mount l.c.:
*1922/85 Kostümierte Puppen*

PROVENANCE:
Purchased from the artist's estate by Karl Nieren-
dorf, New York, 1947
Acquired with the Estate of Karl Nierendorf, 1948

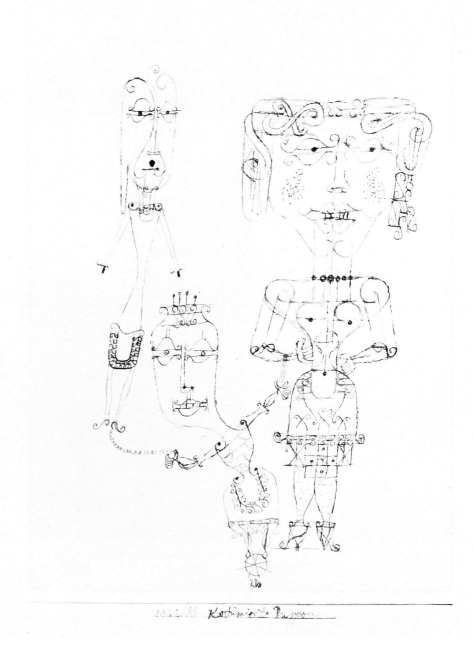

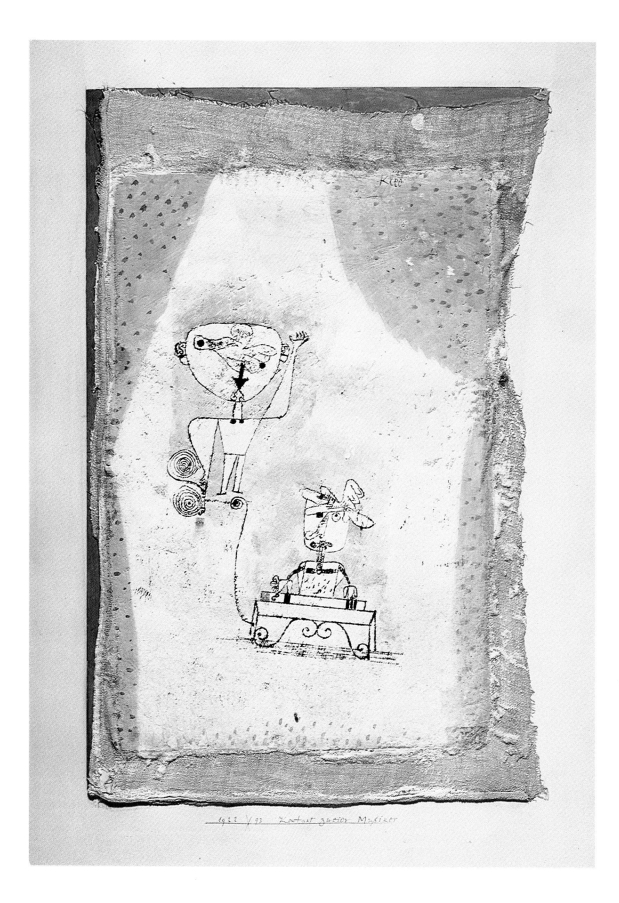

**23**

*Contact of Two Musicians.* 1922
*(Kontakt zweier Musiker)*

OK    *1922, 93 Kontakt zweier Musiker Ölfarbezeich-
nung und Aquarell Nesselstoff, kreidegrundiert (A)*

48.1172 x 527

Watercolor and oil transfer drawing on chalk-
primed linen gauze mounted on gouache-painted
board: gauze support, ca. 17⅞ x 11½″ (45.4 x 29.2
cm.); board mount, 25¼ x 18⅞″ (64.2 x 47.9 cm.)

Signed on support u.r.: *Klee;* inscribed on mount
l.c.: *1922 x 93 Kontakt zweier Musiker;* l.l.: *Sond.
Cl;* on reverse mount: *Saml. K Privatbesitz*

PROVENANCE:
Purchased from the artist's estate by Karl Nieren-
dorf, 1947
Acquired with the Estate of Karl Nierendorf, 1948

**24**

*Fright of a Girl.* 1922
*(Schreck eines Mädchens)*

OK    *1922, 131 Schreck eines Mädchens Ölfarbe-
zeichnung und Aquarell Deutsches Ingres (A)*

48.1172 x 220

Watercolor and oil transfer drawing on paper
mounted on board: paper support, 11¾ x 8⅞″
(29.9 x 22.2 cm.); board mount, 12⅞ x 9⅛″
(32.7 x 23.2 cm.)

Signed on support l.r.: *Klee;* inscribed on mount l.l.:
*1922/131;* l.r.: *Schreck eines Mädchens*

PROVENANCE:
Purchased from the artist's estate by Karl Nieren-
dorf, New York, 1947
Acquired with the Estate of Karl Nierendorf, 1948

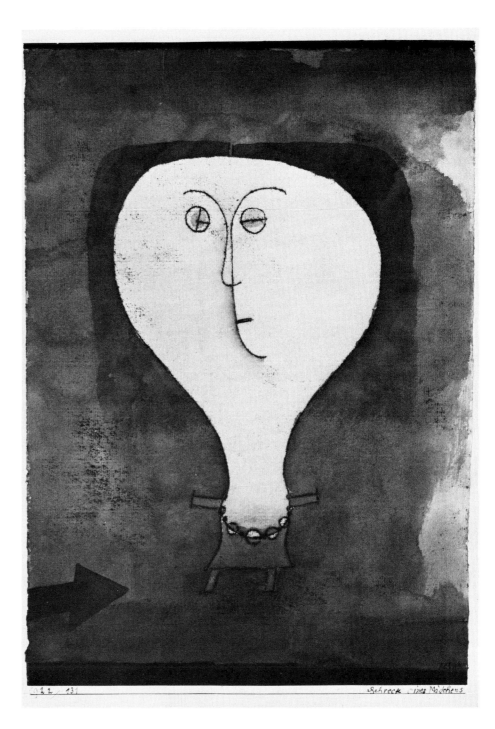

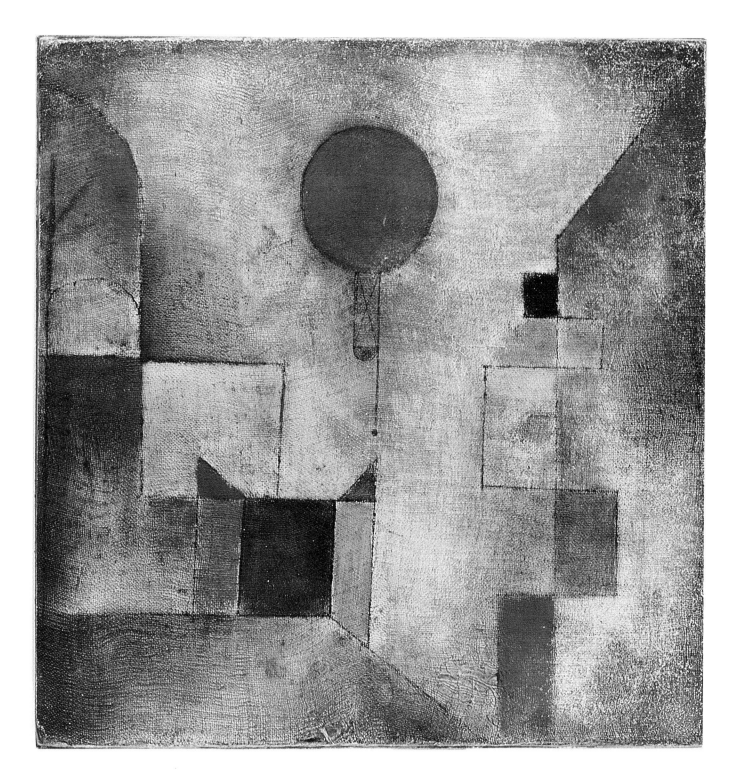

25

*Red Balloon.* 1922
*(Roter Ballon)*

OK   *1922, 179 Roter Ballon Ölbild kleineres
Format Nesselstoff auf Pappe geklebt, kreide-
grundiert (G)*

48.1172 x 524

Oil (and oil transfer drawing?) on chalk-primed
gauze mounted on board, 12½ x 12¼" (31.7 x 31.1
cm.)

Signed and dated l.l.: *Klee/1922/179* (now invisible
to the naked eye but clear under UV); inscribed on
reverse: *1922 III 179/Roter Ballon/Klee./breiter
Rahmen./nicht zu flach/glasen. nicht zu flacher
Rahmen/glasen*

PROVENANCE:
Hermann Lange, Krefeld, by 1931
Karl Nierendorf, New York, by 1947
Acquired with the Estate of Karl Nierendorf, 1948

26

*Tropical Gardening.* 1923
*(Tropische Garten Kultur)*

OK   *1923 55 Tropische Garten Kultur Ölfarbe-
zeichnung und Aquarell Französ Ingres (A)*

37.509

Watercolor and oil transfer drawing on Ingres paper
mounted on paper: paper support with border,
7⅞ x 19¼" (20 x 48.9 cm.); paper mount,
9⅝ x 22¼" (24.4 x 56.4 cm.)

Signed on support c.r. edge: *Klee*; inscribed on
mount l.c.: *1923 III 55 Tropische Garten Kultur*

PROVENANCE:
Purchased from Rudolf Bauer by Solomon R.
Guggenheim, 1937?
Gift, Solomon R. Guggenheim, 1937

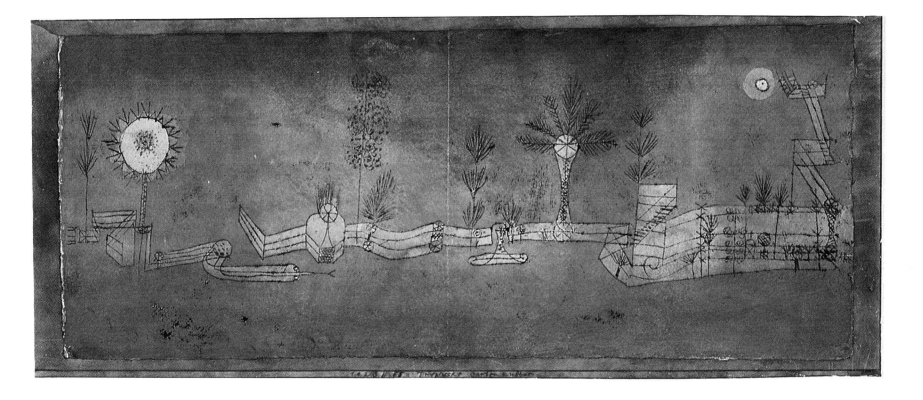

**27**

*Singer of Comic Opera.* 1923
*(Sängerin der komischen Oper)*

OK   *1923, 118 Sängerin der komischen Oper*
*Pinselzeichnung leicht aquarelliert Saugendes*
*Druckpapier*

48.1172 x 61

Watercolor and ink with conté crayon on paper
mounted on board: paper support, 11½ x 9¼″
(29.2 x 23.5 cm.); board mount, 14⅞ x 12″
(37.7 x 30.4 cm.)

Signed on support l.r.: *Klee*; inscribed on mount l.c.:
*1923.118. Sängerin der komischen Oper*

PROVENANCE:
Purchased from the artist's estate by Karl Nieren-
dorf, New York, 1947
Acquired with the Estate of Karl Nierendorf, 1948

**28**

*Tightrope Walker.* 1923
*(Seiltänzer)*

OK   *1923, 138 Seiltänzer Litho (1 farbe) für die*
*Mappe der Marées Gesellschaft (L)*

Kornfeld no. 95 IVc

57.1474

Color lithograph on Bütte paper: plate, 17⅛ x 10¼″
(43.5 x 26.8 cm.); sheet, 20½ x 15″ (52.1 x 38.1 cm.)

Inscribed in pencil l.l.: *23 138*; signed l.r.: *Klee*

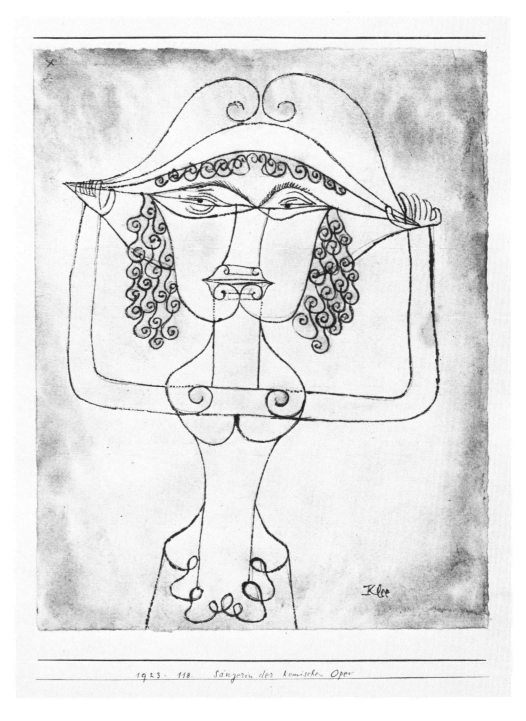

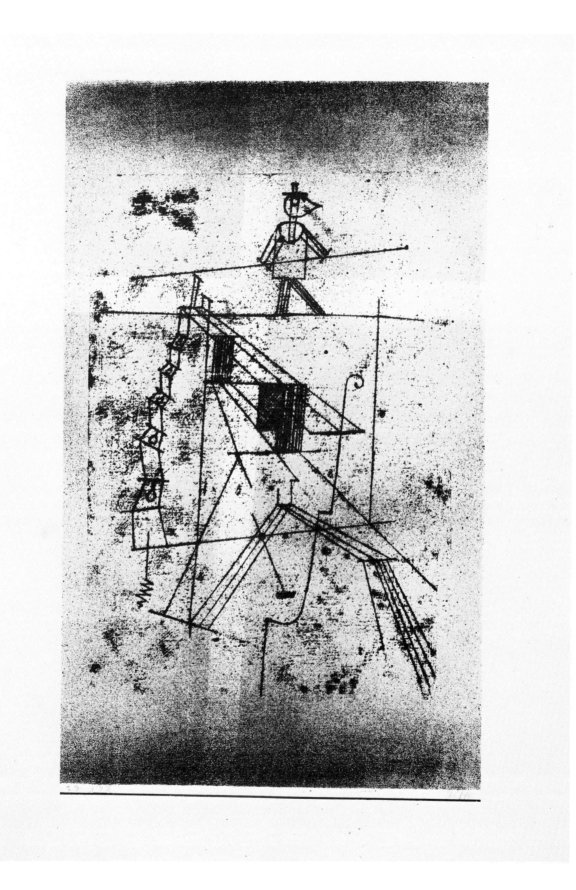

**29**

*Dwarf Herald on Horse. 1923*
*(Zwergherold zu Pferd)*

OK    *1923, 186 Zwergherold zu Pferd Kleines*
*Ölbild graues Ingres aufgeklebt (G)*

48.1172 x 525

Oil with varnish (?) and gold leaf on gray Ingres
paper mounted on board: paper support, 9⅛ x 6⅞″
(23.3 x 17.5 cm.); board mount, 12⅛ x 9⅛″
(30.8 x 23 cm.)

Signed on support l.l.: *Klee*; inscribed on painted
border l.l.: *1923 126 Zwergherold zu Pferd*; l.c. on
mount: *III*

PROVENANCE:
Karl Nierendorf, New York, by 1947
Acquired with the Estate of Karl Nierendorf, 1948

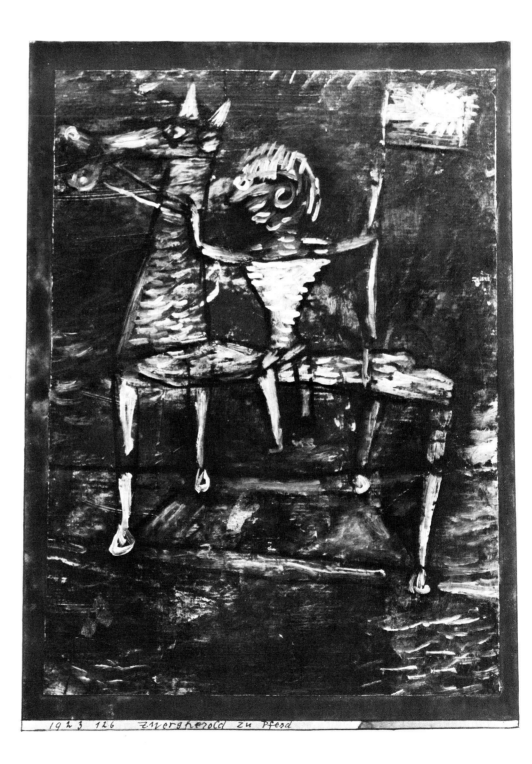

**30**

*Curtain.* 1924
*(Vorhang; Untitled)*

OK   *1924, 129 Vorhang kl. aquarell Nesselstoff*
*aufgeklebt Krapplack Kleistergrund. Ausserdem 129*
*a, b, und c und d*

71.1936 R 115

Watercolor on chalk-primed linen mounted on
paper, mounted on board, varnished with madder:
linen support, 7⅛ x 3⅝″ (18.1 x 9.2 cm.); board
mount, 11⅛ x 6¾″ (28.2 x 17.2 cm.)

Inscribed on board mount l.l.: *1924.129.b.*; l.r.: *Klee*;
below signature: *für Fraülein Grunow*

PROVENANCE:
Gertrud Grunow, Weimar
Hilla Rebay, Greens Farms, Connecticut
Estate of Hilla Rebay, 1967-71
Acquired from the Estate of Hilla Rebay, 1971

**31**

*Tree Culture.* 1924
*(Baum Kultur)*

OK   *1924, 245 Baum Kultur gr. Aquarell m.*
*Ölf. zeichnung PMT. Italia Ingres (A)*

38.511

Oil transfer drawing with watercolor on paper
mounted on board: paper support with border,
19⅛ x 13¾″ (48.7 x 35 cm.); board mount,
23⅞ x 18¾″ (60.5 x 47.5 cm.)

Signed on support l.l.: *Klee*; inscribed on mount l.l.:
*VIII*; c.: *1924 245 Baum Kultur*

PROVENANCE:
Purchased from Rudolf Bauer, Berlin, 1938

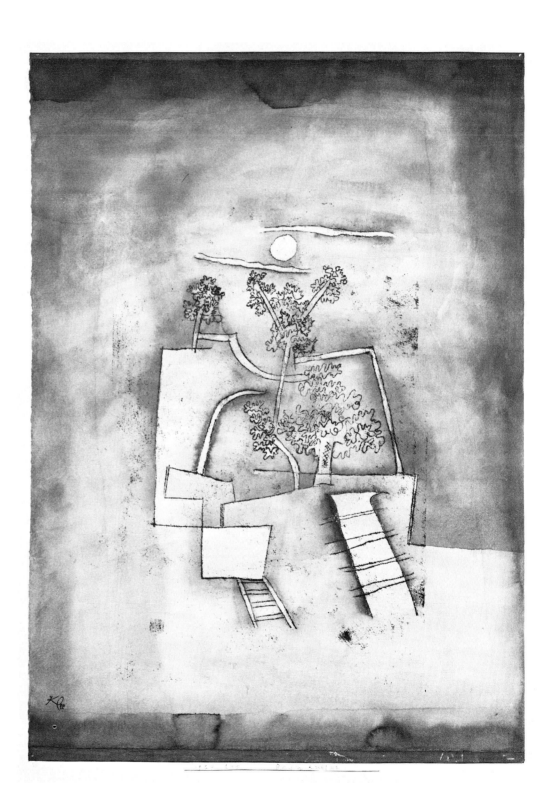

**32**

*A Sketch for a Portrait of a Costumed Lady.* 1924

*(Bildnis Skizze einer Kostümierten Dame)*

OK    1924, 270 *Bildnis Skizze einer kostümierten Dame zeichnung mit breitem Pinsel Briefpapier (Z)*

48.1172 x 124

Ink on paper mounted on board: paper support, 9⅛ x 5¾" (23.2 x 14.6 cm.); board mount, 12¾ x 9⅞" (32.4 x 25.1 cm.)

Signed and inscribed on support l.l.: *Klee*; l.r.: *241212*; on mount l.c.: *1924 270 Bildnis Skizze einer kostümierten Dame*

PROVENANCE:
Karl Nierendorf, New York, by 1947
Acquired with the Estate of Karl Nierendorf, 1948

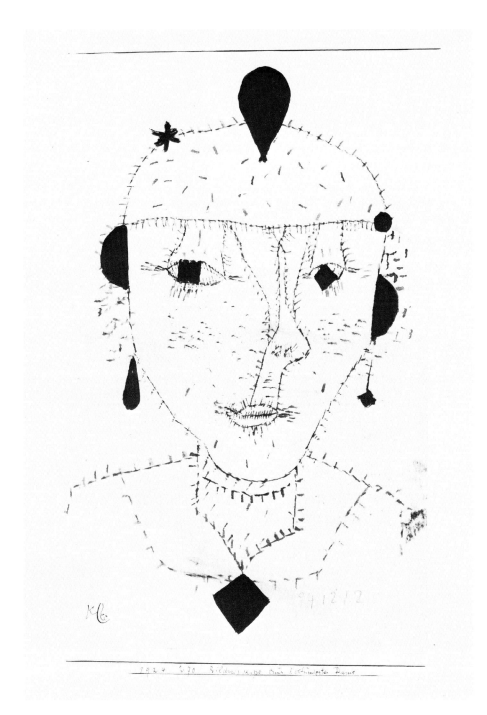

45

**33**

*Signs in the Sky.* 1924
*(Landschaft mit Himmelszeichen)*

Because of title and style, the work may be that
described in the OK as: *1924, 78 Landschaft mit
Himmelszeichen Ölfarben Papier aufgeklebt (G)*

48.1172 x 110

Oil on paper mounted on paper: paper support,
7⅞ x 11¼″ (19.7 x 28.6 cm.); paper mount,
8⅜ x 11¾″ (21.3 x 29.9 cm.)

Signed u.r.: *Klee*; inscription on mount now cut
away

PROVENANCE:
Karl Nierendorf, New York, by 1941
Acquired with the Estate of Karl Nierendorf, 1948

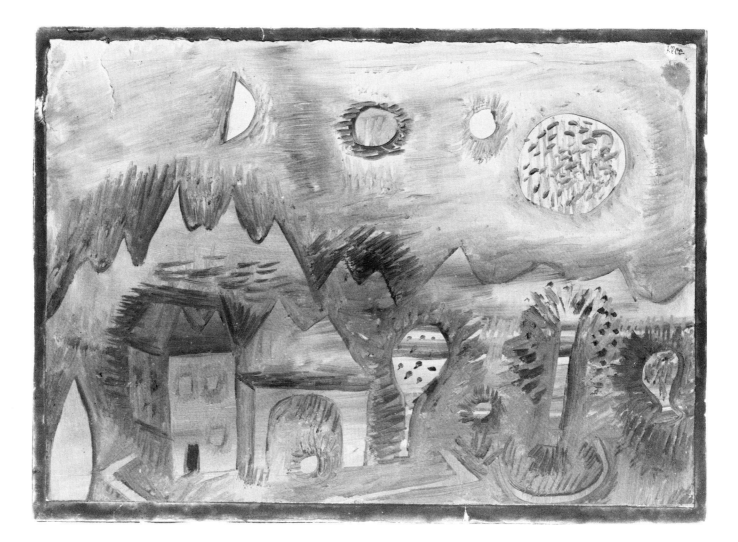

**34**

*Bearded Man (Head). 1925*
*(Bärtiger Mann [Kopf])*

OK    *1925, 84 (R4) Kopf Litho (L)*

Kornfeld no. 98 Ab

48.1172 x 365.6

Lithograph on white wove paper: image, 8¾ x 6″
(22.3 x 15.3 cm.); sheet, 11⅛ x 8¾″ (28.2 x 22.2 cm.)

Inscribed on plate l.c.: *Kl//1925. R 4.*; signed in
pencil l.r.: *Klee*

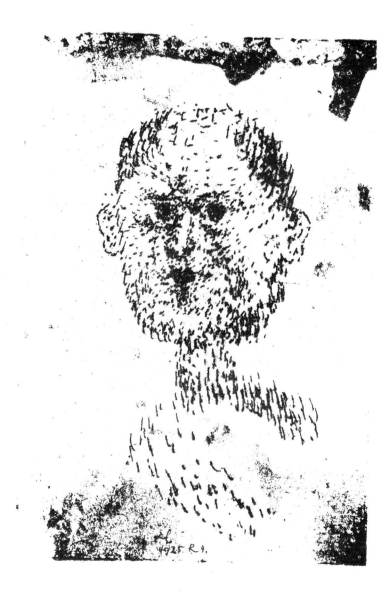

The pinnacle of Klee's structured Bauhaus style may well have been reached in his famous *Highways and Byways,* 1929, painted after the Bauhaus had moved from Weimar to Dessau. This fairly large oil on canvas is now in the Wallraf-Richartz Museum in Cologne. But the Guggenheim's *In the Current Six Thresholds* of the same year also embodies an almost Neo-Plastic reductiveness tempered by a warm and subtle palette. Through such devices Klee substitutes his own stylistic marks for the attributes of the *de Stijl* movement. Both works, incidentally, are spiritual fruits of an Egyptian trip Klee gave himself for his fiftieth birthday, a trip which fulfilled for the completely mature artist an inspirational purpose analogous to that served by his youthful journey to North Africa.

**35**

*Owl Comedy.* 1926
*(Eulen Komoedie)*

OK    *1926, 48 (N.8.) Eulenkomödie grosse Feder-zeichng und Aquarell deutsch Ingres weiss (A)*

39.512

Gouache and ink with airbrush on paper mounted on paper: paper support, 12½ x 18½″ (31.7 x 46.9 cm.); paper mount, 18 x 24″ (45.8 x 61 cm.)

Signed on support l.r.: *Klee*; inscribed on mount l.l.: *1926. N. 8. V*; l.r.: *Eulenkomoedie*

PROVENANCE:
Purchased from Rudolf Bauer, Berlin, 1938

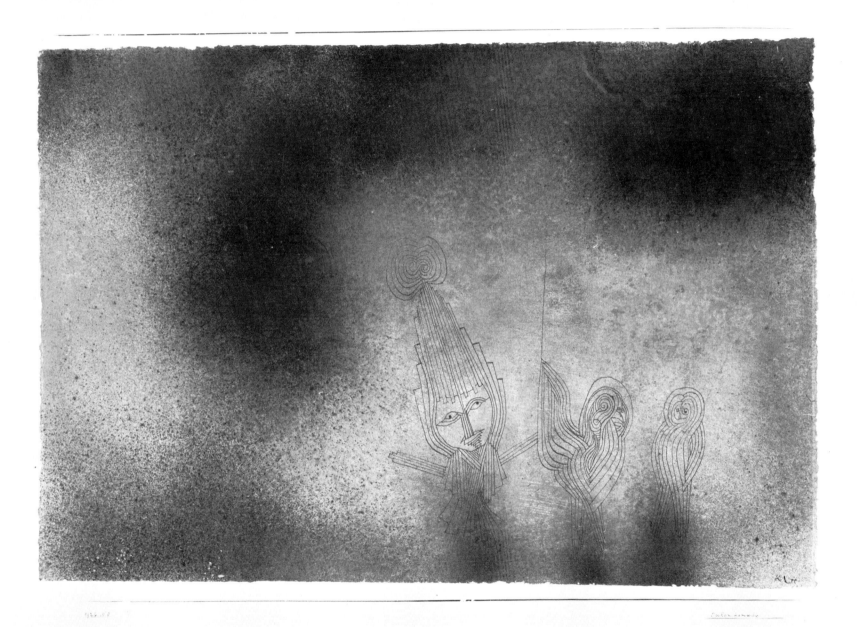

**36**

*Inscription.* 1926
*(Inschrift)*

OK   *1926, 17 (K.7.) Inschrift Federzeichnung*
*aquarelliert deutsch Ingres weiss*

41.343

Watercolor and ink on paper mounted on board:
paper support, 9¼ x 5¾″ (23.5 x 14.6 cm.); board
mount, 12¼ x 8¾″ (31.1 x 22.2 cm.)

Signed on support u.r.: *Klee*; inscribed on mount
l.l.: *I*; l.c.: *1926. K. 7. Inschrift*

PROVENANCE:
Purchased from the artist by Hilla Rebay, Greens
Farms, Connecticut, 1930
Transferred by Hilla Rebay to Solomon R. Guggen-
heim, New York, 1938
Gift, Solomon R. Guggenheim, 1941

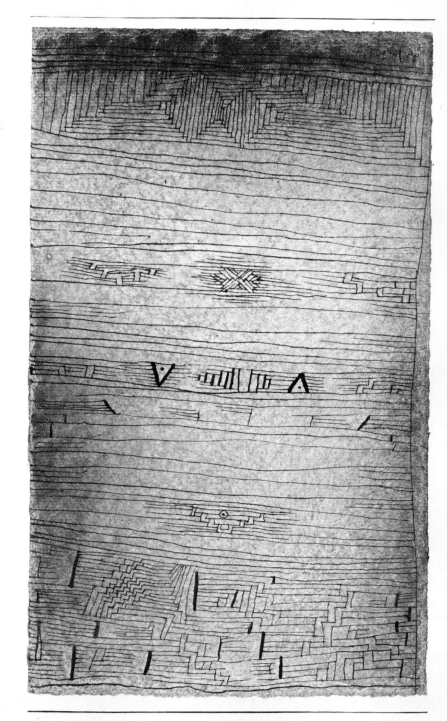

**37**

*Naked Lady.* 1926
*(Nackte Frau)*

OK    *1926, 237 (X.7.) nackte Frau Federzeichnung*
*deutsch Ingres*

48.1172 x 122

Ink on paper mounted on paper: paper support,
10⅛ x 11⅞″ (25.7 x 30 cm.); paper mount,
14⅝ x 14¾″ (37.2 x 37.4 cm.)

Signed on support u.l.: *Klee*; inscribed on mount l.c.:
*1926 X 7 nackte Frau*

PROVENANCE:
Karl Nierendorf, New York, by 1947
Acquired with the Estate of Karl Nierendorf, 1948

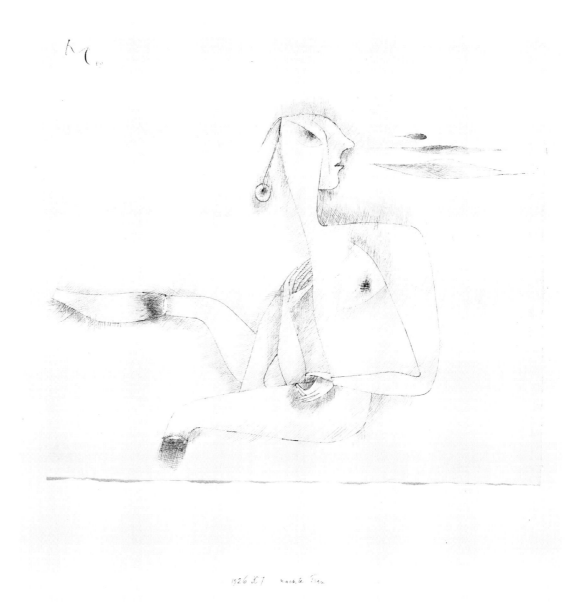

**38**

*Pagodas on Water.* 1927
*(Pagoden am Wasser)*

OK   *1927, 39 (M 9) Pagoden am Wasser*
*Federzchng deutsch Ingres (Z)*

48.1172 x 147

Ink on paper mounted on paper: paper support,
19 x 12¼″ (48.2 x 31.1 cm.); paper mount,
23½ x 16¼″ (59.7 x 41.3 cm.)

Signed on support u.l.: *Klee*; inscribed on mount l.c.:
*1927 M.9. Pagoden am Wasser*

PROVENANCE:
Karl Nierendorf, New York, by 1947
Acquired with the Estate of Karl Nierendorf, 1948

**39**

*Fleeing Ghosts (Spooks).* 1927
*(Spukhaftes)*

OK    *1927, 109 (A 9) Spukhaftes Rohrfederzeichng
franz. Ingres tonig Canson (Z)*

75.2198

Ink on paper mounted on board: paper support,
9⅝ x 12⅛″ (24.4 x 30.8 cm.); board mount,
13½ x 13½″ (34.3 x 34.3 cm.)

Signed on support l.r.: *Klee*; inscribed on mount l.c.:
*1927 A 9 Spukhaftes*

PROVENANCE:
Purchased from Klee Gesellschaft, Bern, by Galerie
Rosengart, Lucerne, 1951
Purchased from Galerie Rosengart by Katharine
Kuh, Chicago, 1951
Gift, Katharine Kuh, New York, 1975

**40**

*Verging on Despair, Portrait.* 1927
*(Bald verzweifelnd, Bildnis)*

OK   *1927, 160 (F.10.) bald verzweifelnd, Bildnis*
*Rohrfederzeichng deutsch. Ingres (Z)*

48.1172 x 487

Ink on paper mounted on paper: paper support,
18¼ x 12″ (46.4 x 30.5 cm.); paper mount,
25½ x 18½″ (64.8 x 47 cm.)

Signed on support u.r.: *Klee*; inscribed l.c. on mount:
*1927 F. 10 bald verzweifeldnd, Bildnis*

PROVENANCE:
Purchased from the artist's estate by Karl Nierendorf, New York, 1947
Acquired with the Estate of Karl Nierendorf, 1948

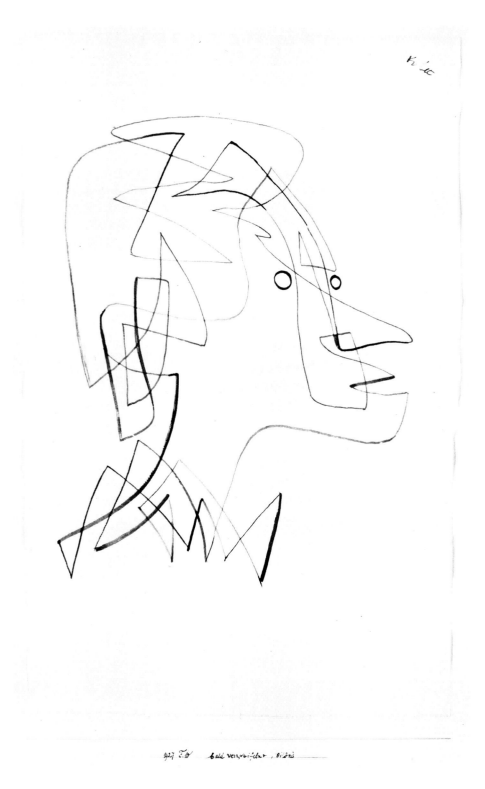

**41**

*Portrait Sketch of Mrs. Hck. 3. 1927*
*(Bildnis Skizze Frau Hck. 3)*

OK   *1927, 174 (H.4) Bildnis Skizze Frau Hck. 3*
*Ölfarbezeichnung (schwächer) Zeitgspap. Kreide-*
*grundt (Z)*

48.1172 x 134

Oil transfer drawing on gesso-primed newspaper
mounted on paper: newspaper support, 14⅝ x 10⅞″
(37.2 x 27.6 cm.); paper mount, 17⅛ x 13¼″
(43.4 x 33.6 cm.)

Signed on support u.l.: *Klee*; inscribed on mount c.:
*1927 H 4. Bildnis Skizze Frau Hck. 3*

PROVENANCE:
Karl Nierendorf, New York, by 1947
Acquired with the Estate of Karl Nierendorf, 1948

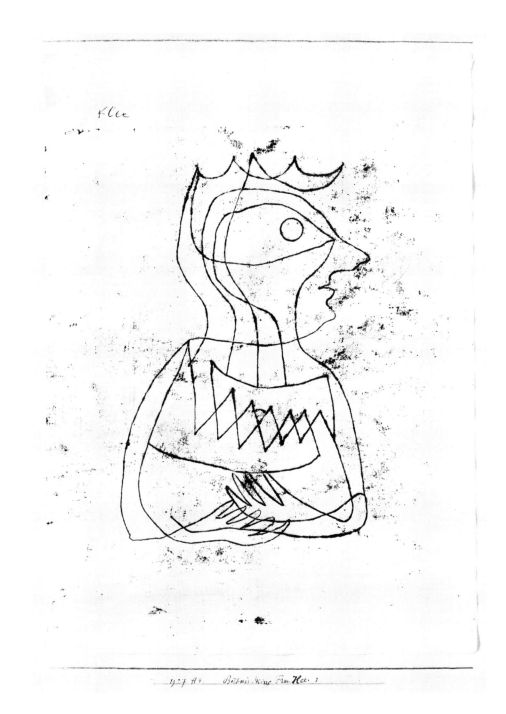

42

*In the Current Six Thresholds.* 1929
*(In der Strömung sechs Schwellen)*

OK    1929, 92 S.2 *in der Strömung sechs Schwellen.*
*Tempera = und Ölfarben 43 x 43 Leinw. auf Keil*
*(Gemälde)*

67.1842

Oil and tempera on canvas, 17⅛ x 17⅛"
(43.5 x 43.5 cm.)

Signed and dated l.r.: *Klee 1929*; inscribed on
stretcher: *in der Strömung Sechs Schwellen / Klee /
1929*

PROVENANCE:
Purchased from the artist by D. H. Kahnweiler
(Galerie Simon), 1936 or 1937
Purchased from Kahnweiler by Curt Valentin,
New York, 1954
G. David Thompson, Pittsburgh, by 1960

Purchased from Thompson by Galerie Beyeler,
Bern, 1960
Purchased from Beyeler by Heinz Berggruen, Paris,
1963
Purchased from Berggruen, 1967

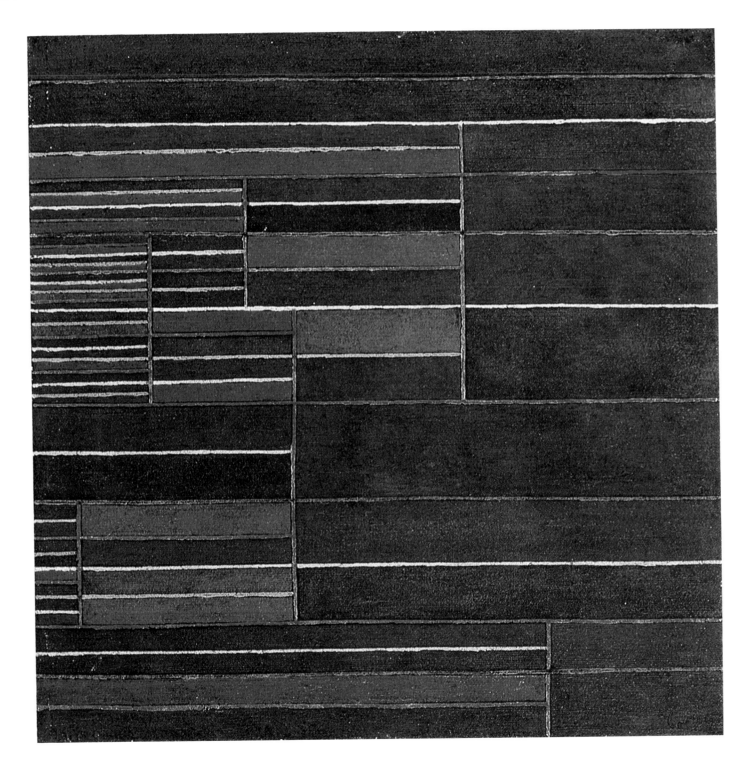

**43**

*Open Book.* 1930
*(Offenes Buch)*

OK    *1930, 206 E6 offenes Buch Wasserfarben*
*gefirnisst Leinwand (Keilrahmen) weisslackgrundiert*
*Orig. leisten 0.45.0.42 (Gemälde)*

48.1172 x 526

Gouache over white lacquer on canvas, 18 x 16¾″
(45.7 x 42.5 cm.)

Signed l.l.: *Klee*; inscribed on stretcher: *1930. E6*
*"Offenes Buch"* Klee

PROVENANCE:
Rolf de Maré, Paris, by 1931
Karl Nierendorf, New York, by 1947
Acquired with the Estate of Karl Nierendorf, 1948

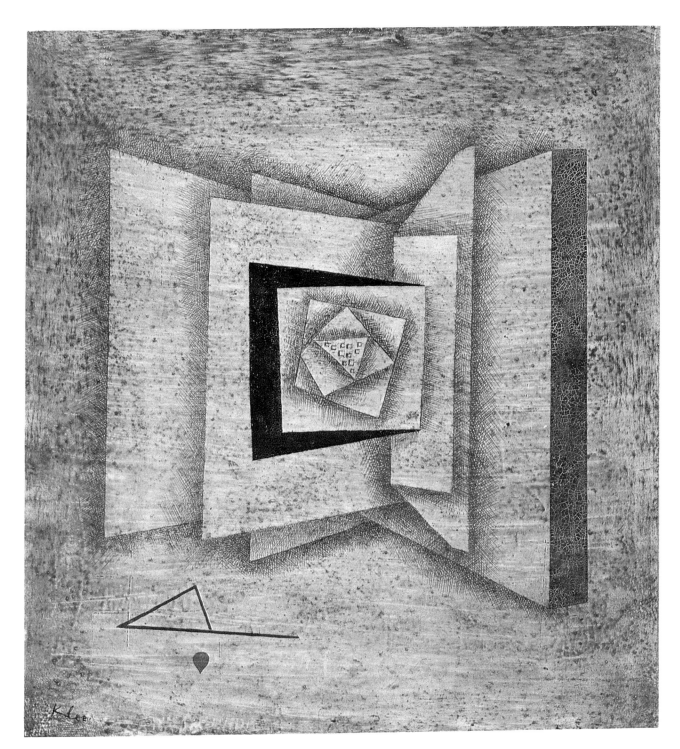

**44**

*Lying as Snow.* 1931
*(Als Schnee liegend)*

OK    *1931, 10 als Schnee liegend Reissfederzeich-*
*nung Französ-Ingres MBM (Zeichnungen)*

48.1172 x 142

Ink on paper mounted on board: paper support,
12¼ x 18¾″ (31.3 x 47.7 cm.); board mount,
18¾ x 24⅝″ (47.6 x 62.6 cm.)

Signed on support l.r.: *Klee*; inscribed on mount l.c.:
*1931. 10. als Schnee liegend*

PROVENANCE:
Purchased from the artist's estate by Karl Nieren-
dorf, New York, 1947
Acquired with the Estate of Karl Nierendorf, 1948

**45**

*The Clown Emigrates.* 1931
*(Der Clown wandert aus)*

OK    *1931, 29 K 9 der Clown wandert aus (Doppel projection mit vertical = achsialer Bindung) Reissfederzeichnung franzö Ingres MBM (Zeichnungen)*

48.1172 x 492

Ink on paper mounted on paper: paper support, 17⅛ x 14⅜″ (43.4 x 36.5 cm.); paper mount, 25⅝ x 19⅝″ (65 x 50 cm.)

Signed on support l.r.: *Klee*; inscribed on mount l.c.: *1931 K 9 der Clown wandert aus*

PROVENANCE:
Purchased from the artist's estate by Karl Nierendorf, New York, 1947
Acquired with the Estate of Karl Nierendorf, 1948

**46**

*In Angel's Keeping.* 1931
*(In Engelshut)*

OK    *1931, 55 L 15 in Engelshut Reissfederzeich-
nung französ Ingres MBM (crème) (Zeichnung)*

48.1172 x 486

Ink on buff paper mounted on board: paper support,
16⅝ x 19⅜″ (42.1 x 49.1 cm.); board mount,
19¾ x 25½″ (50 x 64.9 cm.)

Signed on support l.r.: *Klee*; inscribed on mount l.c.:
*1931. L.15. in Engelshut*

PROVENANCE:
Purchased from the artist's estate by Karl Nieren-
dorf, New York, 1947
Acquired with the Estate of Karl Nierendorf, 1948

**47**

*In Readiness.* 1931
*(Bereitschaft)*

OK    *1931, 232 v. 12 Bereitschaft Bleistift (nach 1928
H 10) französ Ingres d'arches (schwarze Blätter)*

48.1172 x 152

Pencil on paper mounted on paper: paper support,
12¼ x 21″ (31.1 x 53.3 cm.); paper mount,
16⅜ x 25½″ (41.6 x 64.7 cm.)

Signed on support l.l.: *Klee*; inscribed on mount l.l.:
*1931 v. 12*; l.r.: *Bereitschaft (auf Grd. v. 1928 H 10)*

PROVENANCE:
Karl Nierendorf, New York, by 1947
Acquired with the Estate of Karl Nierendorf, 1948

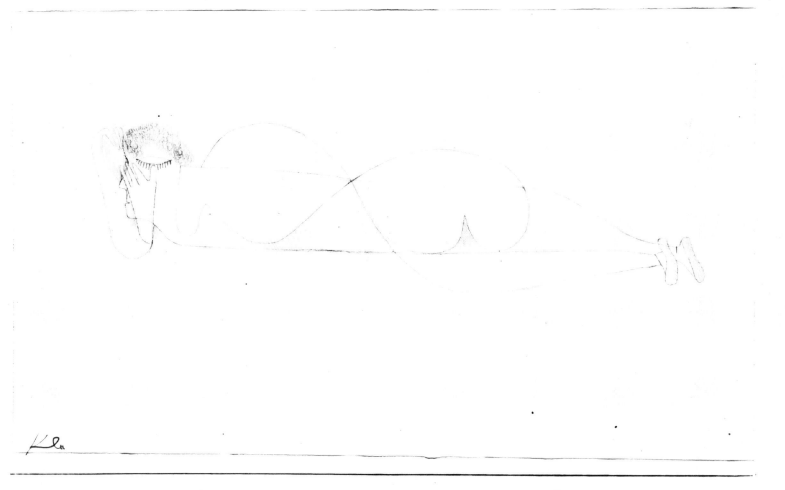

**48**

*A Pious One.* 1931
*(Ein Frommer)*

OK    *1931, 245 W 5 ein Fromer Bleistift französ*
*Ingres d'arches (schwarze Blätter)*

48.1172 x 480

Pencil on paper mounted on paper: paper support,
18⅞ x 16¾″ (47.8 x 42.8 cm.); paper mount,
24¼ x 19⅝″ (61.6 x 49.9 cm.)

Signed on support l.l.: *Klee*; inscribed on mount l.c.:
*1931. W.5. ein Frommer*

PROVENANCE:
Purchased from the artist's estate by Karl Nieren-
dorf, New York, 1947
Acquired with the Estate of Karl Nierendorf, 1948

**49**

*Barbarian Sacrifice.* 1932
*(Barbaren-Opfer)*

OK    *1932, 12 Barbaren opfer Wasserfarben französ*
*Ingres MBM (farbiges Blatt)*

69.1893

Watercolor on paper mounted on board: paper
support, 24¾ x 18⅞″ (62.9 x 48 cm.); board mount,
25½ x 19⅝″ (64.8 x 49.8 cm.)

Signed on support l.r.: *Klee*; inscribed on mount l.l.:
*1932. 12. IV*; l.r.: *Barbaren-Opfer*

PROVENANCE:
Purchased from Private Collection, Bern, by Galerie
Rosengart, Lucerne, 1952
Purchased from Galerie Rosengart by Frederick C.
Schang, 1952
Purchased from Schang by Saidenberg Gallery,
New York, December 1968
Purchased from Saidenberg Gallery, May 1969

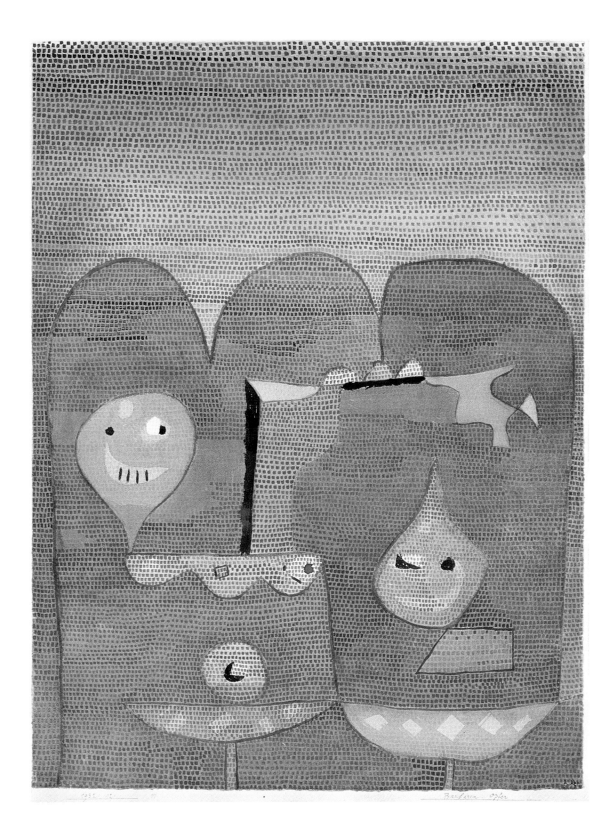

**50**

*Three Young Couples.* 1932
*(Drei junge Paare)*

OK    *1932, 126 qu 6 drei junge Paare Pinselzeich-*
*nung mit Aquarell ital. Ingres mit pastosem Kreide-*
*grund (farbiges Blatt)*

48.1172 x 74

Gouache and ink on primed paper mounted on
paper: paper support, 8⅞ x 14⅝″ (22.6 x 37.1 cm.);
paper mount, 12¼ x 17⅛″ (31.1 x 43.4 cm.)

Signed on support l.r.: *Klee*; inscribed on mount l.l.:
*1932 qu 6*; l.r.: *drei junge Paare*

PROVENANCE:
Purchased from the artist's estate by Karl Nieren-
dorf, New York, 1947
Acquired with the Estate of Karl Nierendorf, 1948

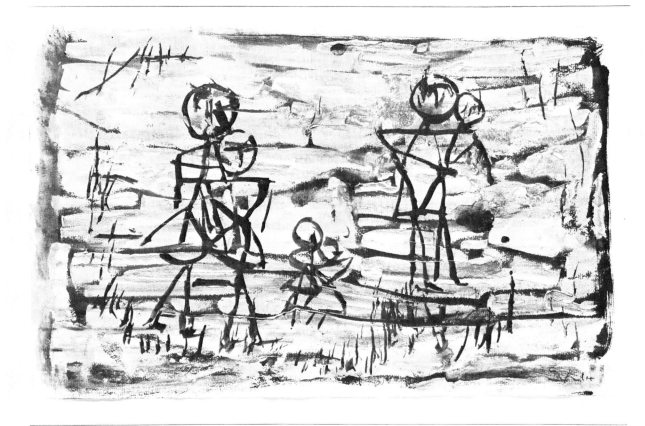

**51**

*Public Duel.* 1932
*(Öffentliches Duell)*

OK    *1932, 131 qu 11 öffentliches Duell Pinsel-
zeichng und Aquarell Seidenpapier (farbiges Blatt)*

48.1172 x 64

Watercolor and ink on tissue paper mounted on
board: paper support, 19¼ x 14¾″ (48.9 x 37.6 cm.);
board mount, 25⅝ x 19⅝″ (65 x 49.9 cm.)

Signed on support u.r.: *Klee*; inscribed on mount l.c.:
*1932 qu 11 öffentliches Duell*

PROVENANCE:
Purchased from the artist's estate by Karl Nieren-
dorf, New York, 1947
Acquired with the Estate of Karl Nierendorf, 1948

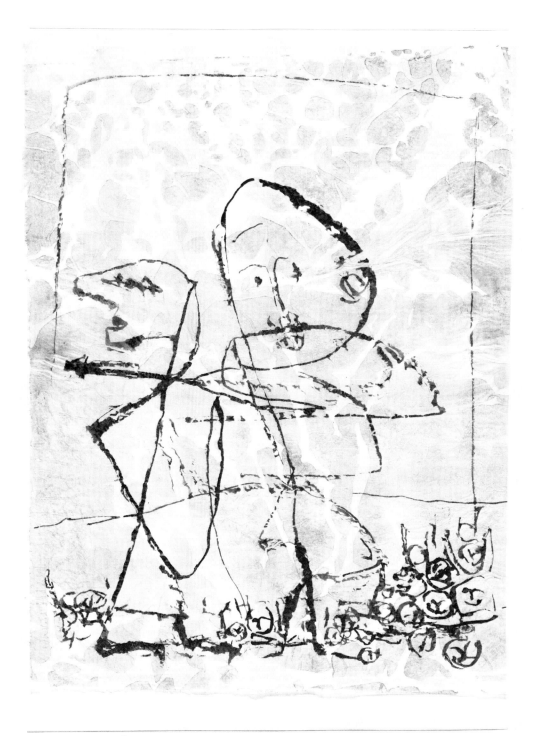

**52**

*Hat, Lady and Little Table.* 1932
*(Hut, Dame und Tischchen)*

OK   *1932, 263 (X3) Hut, Dame und Tischchen mit*
*gips grundiertes Sackleinen, mit Deckfarben und*
*Aquarellfarben übermalt*

77.2292

Oil and watercolor on gesso-primed burlap mounted
on board: burlap support, 25 x 14″ (63.5 x 35.6 cm.);
board mount, 26¼ x 14¼″ (66.7 x 36.2 cm.)

Signed on support u.l.: *Klee*; inscribed on mount l.l.:
*SCl 1932 X3*; c.: *Hut Dame und Tischchen*; u.l.:
*für die Monogr. bestimmt Hut Dame und Tischchen*

PROVENANCE:
Private Collection, Switzerland
Sold at auction, Kornfeld und Klipstein, Bern, 1970,
to Mr. W. Helfer, Bern
Purchased through Galerie Schindler, Bern, 1977

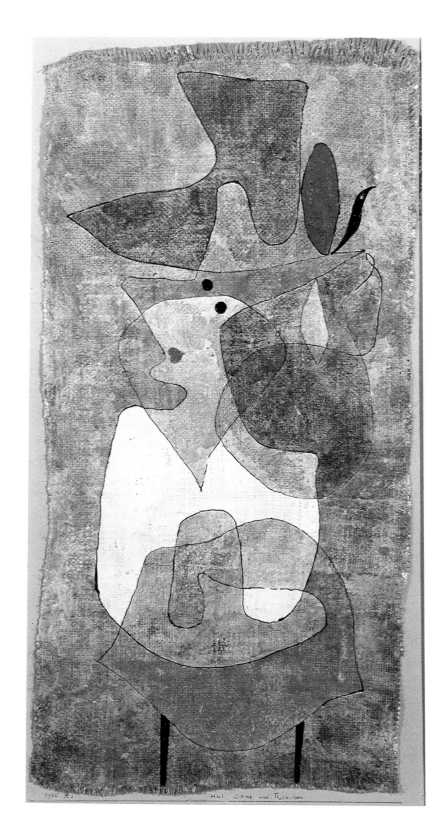

**53**

*Loose Coil.* 1932
*(Loser Knäul)*

OK   *1932, 232 V 12 loser Knäul schwarze Aquarell-*
*farben französ Ingres MBM (einfarbiges Blatt)*

48.1172 x 138

Watercolor on paper mounted on board: paper
support, 6⅝ x 18¾″ (16.8 x 47.6 cm.); board mount,
16⅜ x 25½″ (41.9 x 64.8 cm.)

Signed on support l.r.: *Klee*; inscribed on mount l.l.:
*1932 V 12*; l.r.: *loser Knäul*

PROVENANCE:
Karl Nierendorf, New York, by 1947
Acquired with the Estate of Karl Nierendorf, 1948

**54**

*Two Ways.* 1932
*(Zwei Gänge)*

OK    *1932, 236 V16 zwei Gänge schwarze Aquarell-*
*farben ital Ingres PMF (einfarbiges Blatt)*

48.1172 X 139

Watercolor on paper mounted on paper: paper
support, 12¼ x 19″ (31.3 x 48.4 cm.); paper mount,
17½ x 24″ (44.3 x 61 cm.)

Signed on support l.l.: *Klee*; inscribed on mount
l.l.: *1932 V16*; l.r.: *Zwei Gänge*

PROVENANCE:
Karl Nierendorf, New York, by 1947
Acquired with the Estate of Karl Nierendorf, 1948

Klee's even artistic pace falters in 1933: this is partly due to the political events which numbered among its consequences the closing of the Bauhaus (which he had left in 1931) but also to his failing health soon after his return to his native Bern in 1933. There is a point in the mid-1930's, painfully noticeable in the Guggenheim's sequence of works, in which Klee's creative production is much reduced. But the major *New Harmony*, of 1936, testifies to a partial recovery that carries Paul Klee to the end of his life, allowing him to create some of his most moving works. *Death and Fire*, painted in the year of his death, 1940, in the Klee *Stiftung* of the Kunstmuseum Bern, illustrates to a high degree the admirable achievement of the artist in his last period. Detachment without loss of passion and irony without harshness constitute the emotional base upon which the final works are predicated. Formal problems, now wholly resolved, no longer require visual emphasis. Klee's work assumes a self-generated, transcendent character, as if it were guided from some remote otherworldly point. No prime example from this period is found in the Guggenheim Collection at present, but *Boy with Toys*, a pastel, also of the last year of Klee's life, conveys, through its dismembered forms, the pathos and tragedy that appear with increasing force and frequency in the ailing artist's painting.

In an early moment of foreboding, Paul Klee wrote what was later transformed into his epitaph: "I cannot be grasped in the here and now, for I live just as well with the dead as with the unborn, somewhat closer to the heart of creation than usual, but far from close enough."

**55**

*Classical Ruins.* 1933
*(Klassische Trümmer)*

OK   *1933, 19 K 19 Klassische Trümmer Pinsel-
zeichnung japan (einfarbiges Blatt)*

48.1172 x 144

Watercolor on paper mounted on board: paper
support, 14 x 20″ (35.6 x 51 cm.); board mount,
16⅛ x 21″ (41 x 53.2 cm.)

Signed on support u.l.: *Klee*; inscribed on mount l.l.:
*1933 K 19.*; l.r.: *Klassische trümmer*

PROVENANCE:
Karl Nierendorf, New York, by 1947
Acquired with the Estate of Karl Nierendorf, 1948

**56**

*New Harmony.* 1936
*(Neue Harmonie)*

OK   *1936, 24 K 4 0,93 0,66 Neue Harmonie
Ölfarben Leinwand auf Keilrahmen (Tafel)*

71.1960

Oil on canvas, 36⅞ x 26⅛″ (93.6 x 66.3 cm.)

Signed u.r.: *Klee*

PROVENANCE:
Purchased from the artist by D. H. Kahnweiler
(Galerie Simon), Paris, 1937
Sent on consignment to Nierendorf Gallery,
New York, 1939
Benjamin Baldwin, New York, by 1949
Purchased from Baldwin at Parke-Bernet auction,
March 10, 1971, by Heinz Berggruen, Paris
Purchased from Berggruen by Galerie Beyeler,
April 1971
Purchased from Galerie Beyeler, 1971

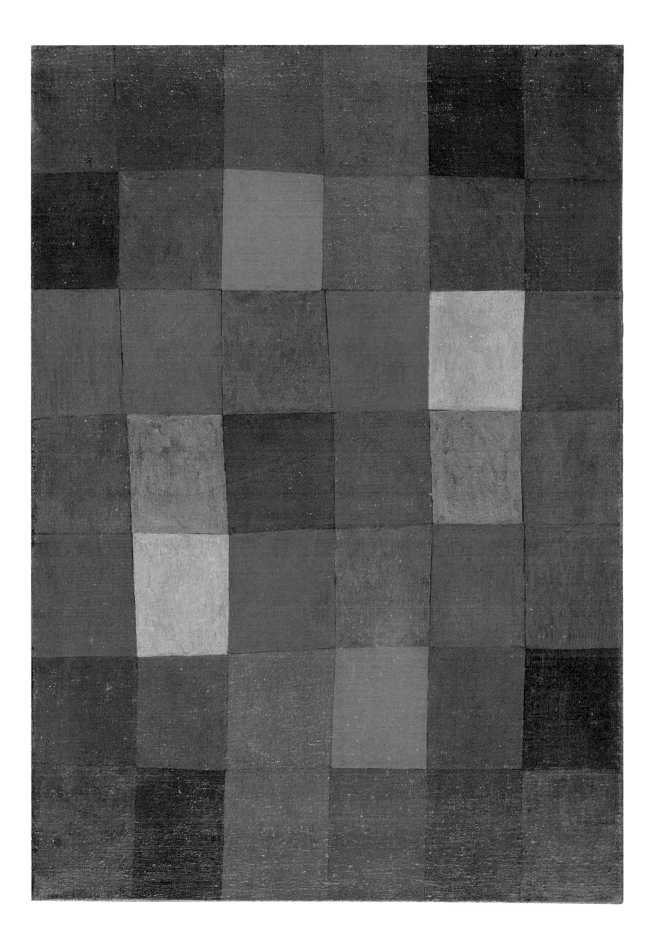

**57**

*Pomona Growing Up.* 1937
*(Pomona heranwachsend)*

OK   *1937, 33 K 13 Pomona heranwachsend*
*Ölfarben Fabriano Ol blau grund (Blatt, mehrfarbig)*

38.516

Oil on paper mounted with cloth strips on paper:
paper support including cloth strips, 21⅞ x 14½″
(55.5 x 37.5 cm.); paper mount, 25⅜ x 19⅝″
(64.4 x 49.8 cm.)

Signed on support l.l.: *Klee*; inscribed on mount l.c.:
*137. K. 13. Pomona heranwachsend*

PROVENANCE:
Purchased from the artist, 1938

**58**

*Viaducts Break Ranks.* 1937
*(Brückenbogen tretten aus der Reihe)*

OK   *1937, 111 p 11 Brückenbogen tretten aus der*
*Reihe Kohl u Rötel rötl. Tischtuch mit Sternen*
*(Blatt, mehrfarbig)*

48.1172 x 59

Charcoal on cloth mounted on paper: cloth support,
16¾ x 16½″ (42.6 x 42 cm.); paper mount,
19⅝ x 18⅜″ (50 x 46.8 cm.)

Signed on support l.r.: *Klee*

PROVENANCE:
Karl Nierendorf, New York, by 1942
Acquired with the Estate of Karl Nierendorf, 1948

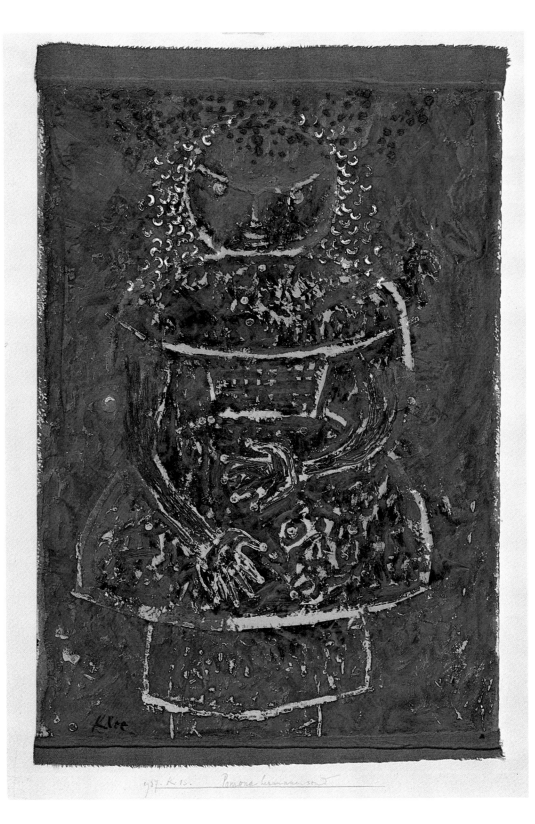

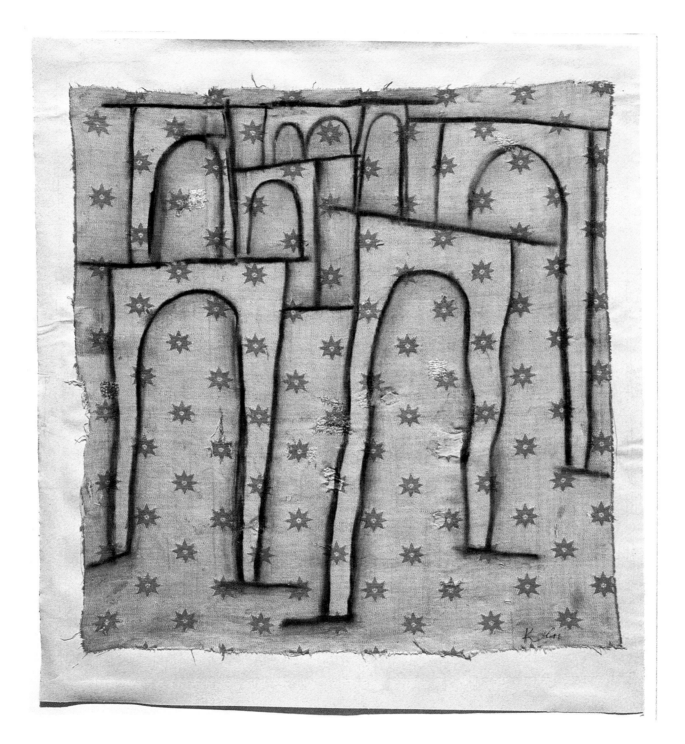

**59**

*Fruitfulness.* 1937
*(Fruchtbarkeit)*

OK    *1937, 115 p 15 Fruchtbarkeit Kohle u.
Aquarellf. Zeitg. = Papier Kreide Kleister gdt.
(Blatt, mehrfarbig)*

38.517

Watercolor on textured plaster wash on newspaper
mounted on paper: newspaper support, 19⅛ x 13⅛"
(48.7 x 33.3 cm.); paper mount, 25 x 19"
(63.5 x 48.2 cm.)

Signed on support u.r.: *Klee*; inscribed on mount l.l.:
*VII*; l.c.: *1937 p 15 Fruchtbarkeit*

PROVENANCE:
Purchased from the artist, 1938

**60**

*Peach Harvest.* 1937
*(Pfirsich-Ernte)*

OK    *1937, 117 p 17 Pfirsich-Ernte Kohle u.
Aquarellf. Kreide Kleistergdt. (Blatt, mehrfarbig)*

38.518

Watercolor on chalk-gesso primed paper mounted
with linen strips on paper: paper support including
strips, 21¾ x 17⅛" (55.2 x 43.5 cm.); paper mount,
25¼ x 19⅝" (64.1 x 49.9 cm.)

Signed on support u.l.: *Klee*; inscribed on mount l.c.:
*1937. p. 17. Pfirsich-Ernte*

PROVENANCE:
Purchased from the artist, 1938

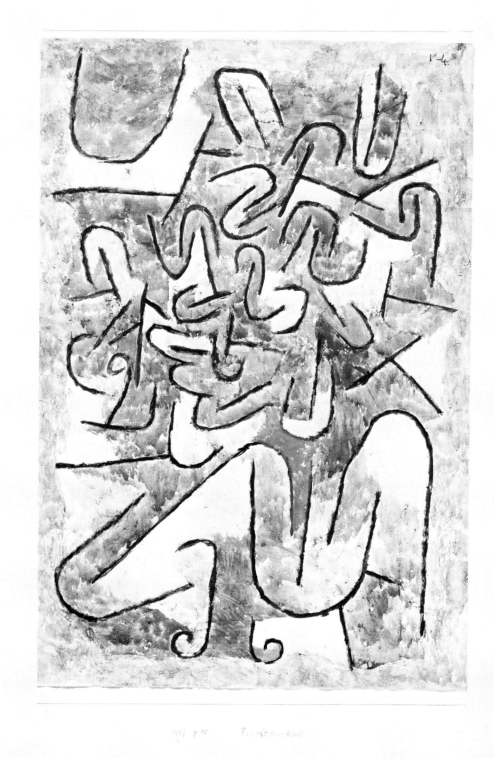

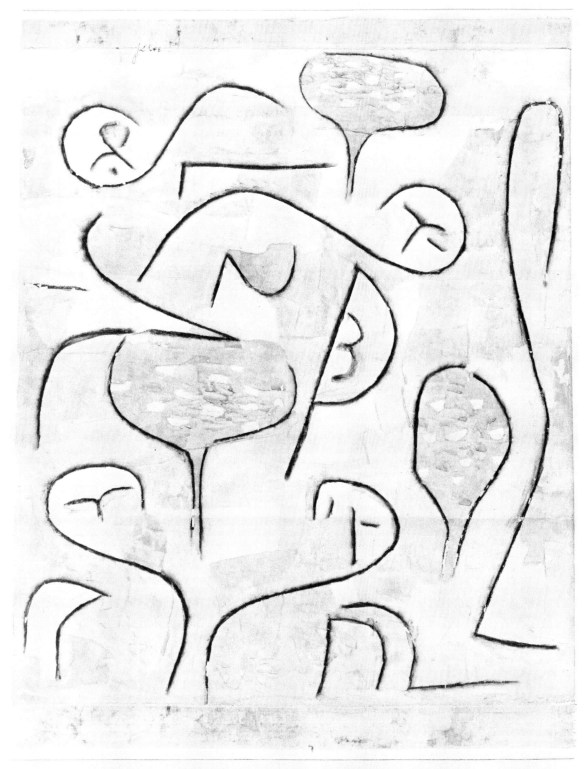

1937. f.17    Pfirsich-Ernte

**61**

*Park near B.* 1938
*(Park bei B.)*

OK    1938, 41 E 1 *Park bei B. Wasserf. Papier dick Kreidegrdt (Blatt, mehrfarbig)*

71. 1936 R112

Watercolor on textured plaster wash on paper mounted on paper; paper support, 9 x 6¼″ (22.9 x 15.9 cm.); paper mount, 14¾ x 11⅞″ (37.4 x 30.2 cm.)

Signed on support u.l.: *Klee;* inscribed on mount l.c.: *1938. E. 1 Park bei B. // für Hilla von Rebay // in Freundschaft*

PROVENANCE:
Purchased by Hilla Rebay, Greens Farms, Connecticut, 1938?
Estate of Hilla Rebay, 1967-71
Acquired from the Estate of Hilla Rebay, 1971

**62**

*Rolling Landscape.* 1938
*(Wogende Landschaft)*

OK    1938, 409 Y9 *Wogende Landschaft Aquarell-farben Segelleinen mit gestaltetem Kreide = Kleister grund (Blatt, mehrfarbig)*

48.1172 x 529

Gouache on chalk-and-glue primed sailcloth, mounted on tempera-painted board: sailcloth support, 15⅞ x 21¼″ (40.2 x 54.2 cm.); board mount, 18½ x 24⅜″ (47.1 x 61.9 cm.)

Signed on support u.l.: *Klee* (now lost through flaking)

PROVENANCE:
Karl Nierendorf, New York, by January 1941
Acquired with the Estate of Karl Nierendorf, 1948

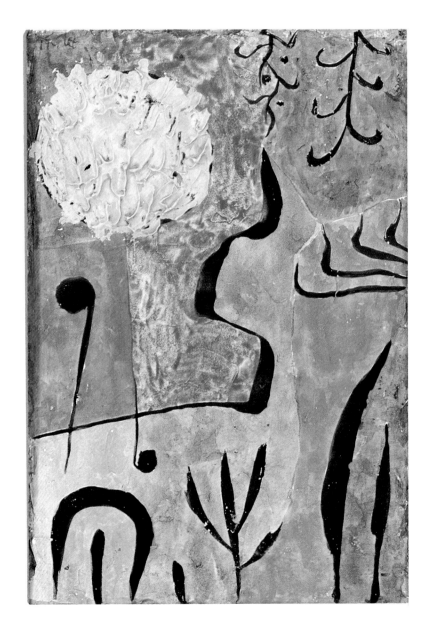

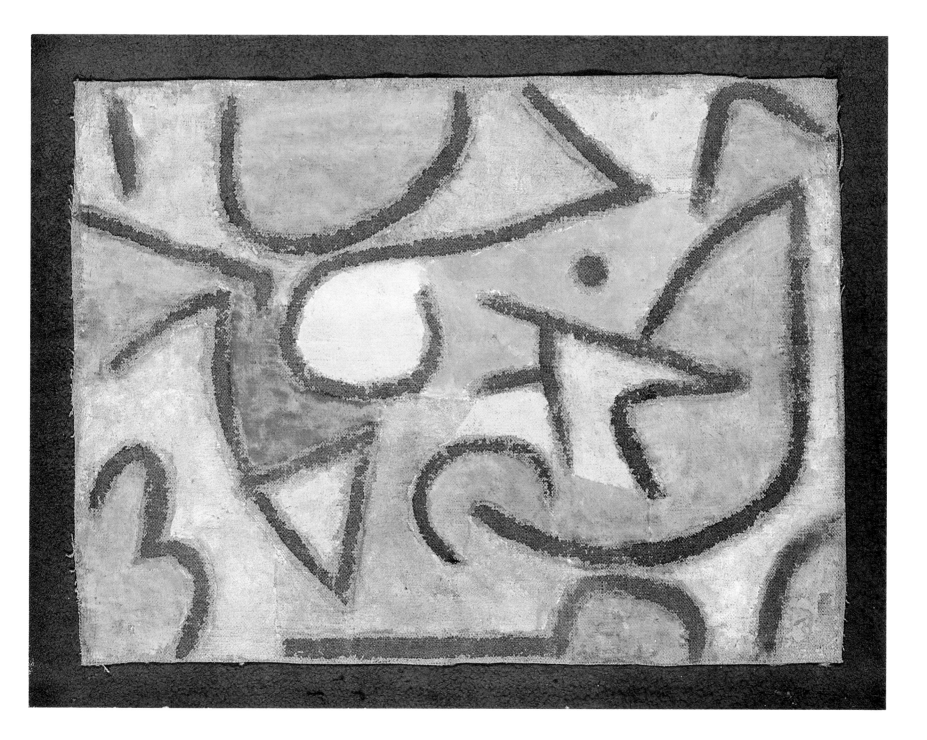

63

*Severing of the Snake.* 1938
*(Zerteilung der Schlange)*

OK   *1938, 262 R2 Zerteilung der Schlange*
*Aquarellfarben auf gestaltetem Kreide—Kleistergnd*
*auf Jute (Blatt, mehrfarbig)*

48.1172 x 57

Gouache on burlap mounted on built up chalk and
gesso-primed burlap, mounted on board: burlap
support, ca. 20½ x 15½″ (52.1 x 39.4 cm.); gesso-
primed mount, 28¼ x 23″ (72 x 58.4 cm.)

Signed on support u.r.: *Klee*

PROVENANCE:
Karl Nierendorf, New York, by February 1940
Mrs. Horatio Gates Lloyd, Haverford, Pennsylvania,
ca. 1944-46?
Returned to Nierendorf, ca. 1946
Acquired with the Estate of Karl Nierendorf, 1948

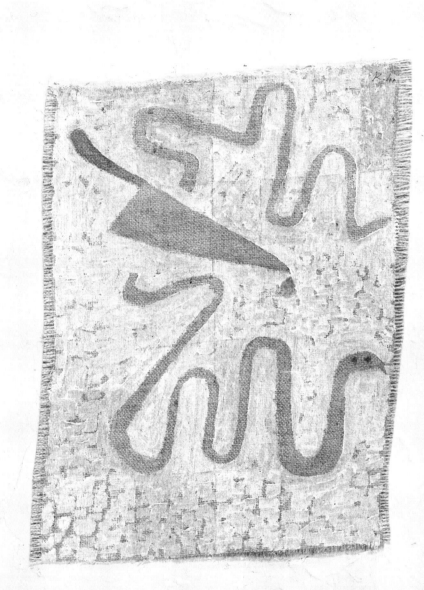

**64**

*Rocks at Night.* 1939
*(Felsen in der Nacht)*

OK    *1939, 83 K3 Felsen in der Nacht Aquarell-
farben Briefpapier mit blauem Kleister grd (Blatt,
mehrfarbig)*

48.1172 x 538

Gouache on primed paper mounted on paper: paper
support, 8¼ x 11⅝″ (20.9 x 29.5 cm.); paper mount,
10⅞ x 14¼″ (27.6 x 36.2 cm.)

Signed on support l.l.: *Klee*; inscribed on mount l.l.:
*1939 K 3*; l.r.: *Felsen in der Nacht*

PROVENANCE:
Purchased from the artist's estate by Karl Nieren-
dorf, New York, 1947
Acquired with the Estate of Karl Nierendorf, 1948

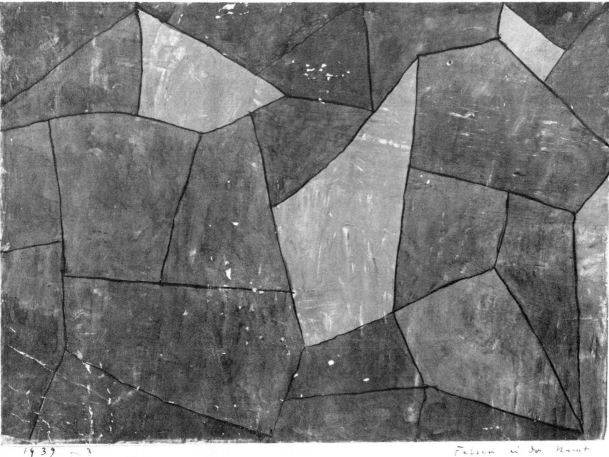

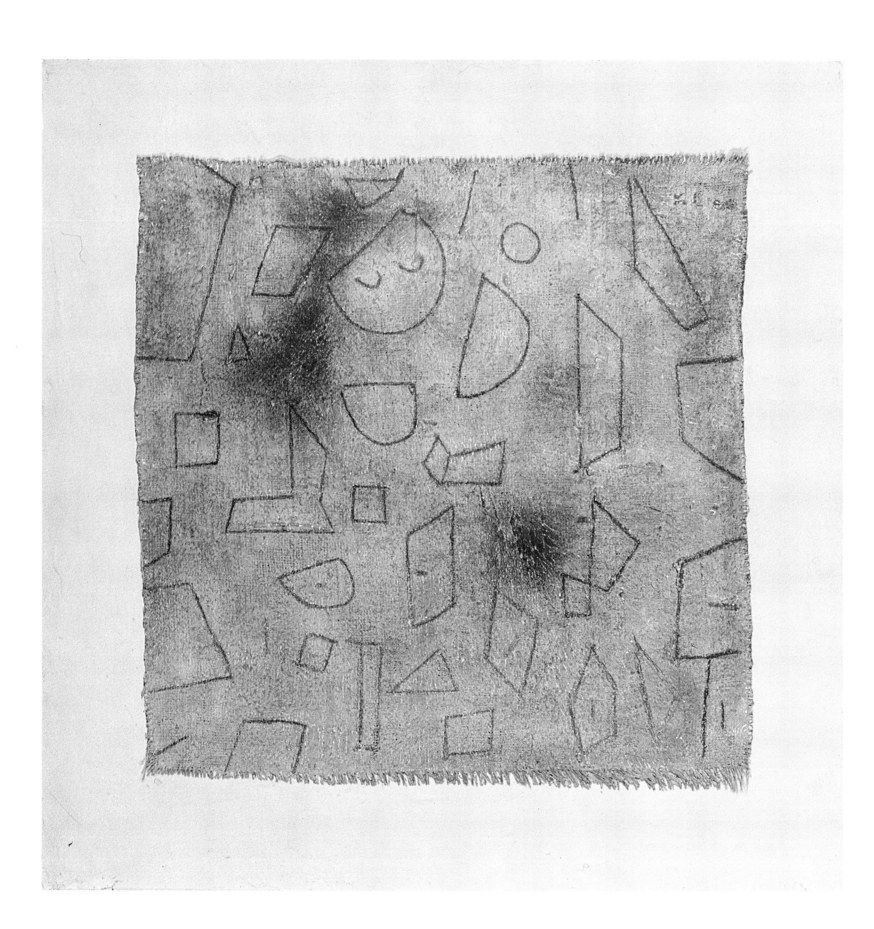

**65**

*Will It Be A Girl?* 1939
*(Wird es ein Mädchen?)*

OK   1939, 384 A4 0.56☐ *Wird es ein Mädchen?
Wasser = & Olfarben Jute gipsgrundiert u.
doubliert (Tafel)*

48.1172 x 58

Oil and gouache on gesso-primed burlap (doubled)
mounted on gessoed board: burlap support,
20¾ x 21″ (52.5 x 53.2 cm.); board mount,
28⅛ x 28″ (71.4 x 71.1 cm.)

Signed on support u.r.: *Klee*

PROVENANCE:
Karl Nierendorf, New York, by 1942
Acquired with the Estate of Karl Nierendorf, 1948

**66**

*A Barren One.* 1939
*(Eine Unfruchtbare)*

OK   1939, 456 D 16 *eine Unfruchtbare Tintenstift
und Aquarellfarben "Biber" Concept Papier (Blatt,
mehrfarbig)*

48.1172 x 72

Watercolor and ink on paper, 10½ x 16¾″
(26.7 x 42.4 cm.)

Signed l.l.: *Klee*

PROVENANCE:
Purchased from the artist's studio by Karl Nieren-
dorf, New York, by 1940
Acquired with the Estate of Karl Nierendorf, 1948

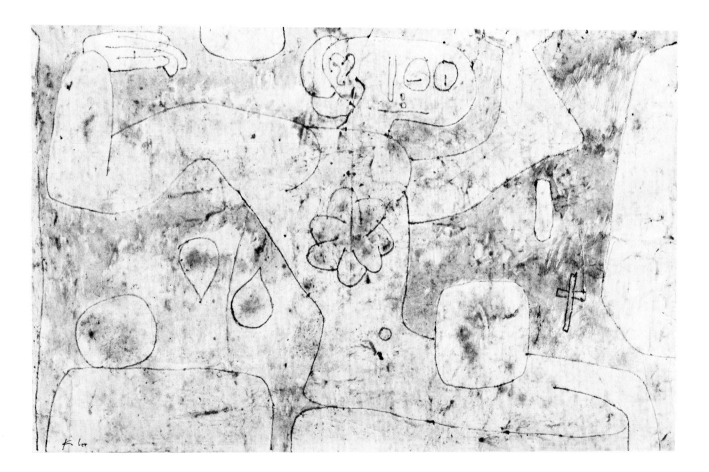

**67**

*Boy with Toys.* 1940
*(Knabe mit Spielsachen)*

OK    1940, 249 M9 *Knabe mit Spielsachen Kleister-*
*farben Biber Concept (Blatt, mehrf)*

48.1172 x 70

Colored paste on paper mounted on paper: paper
support, 11½ x 8¼″ (29.2 x 20.6 cm.); paper mount,
15⅞ x 12¼″ (40.4 x 31.2 cm.)

Signed on support u.r.: *Klee*; inscribed across bot-
tom of mount: *1940 M 9 Knabe mit Spielsachen*

PROVENANCE:
Purchased from the artist's estate by Karl Nieren-
dorf, New York, 1947
Acquired with the Estate of Karl Nierendorf, 1948

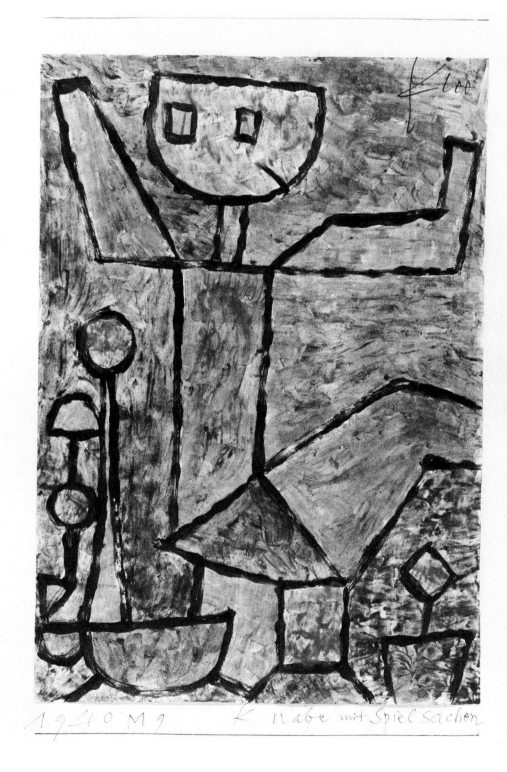

# Selected Bibliography

**By the Artist**

"Die Ausstellung des modernen Bundes im Kunsthaus Zürich," *Die Alpen,* Bern, vol. 6, no. 12, August 1912, pp. 696-704

"Über das Licht," *Der Sturm,* Berlin, vol. 3, no. 144-145, February 1913. Translation of unpublished essay by Robert Delaunay

*Schöpferische Konfession,* Berlin, Reiss, 1920, pp. 28-40. Translated by Norbert Guterman as "Creative Credo" in Werner Haftmann, ed., *The Inward Vision: Watercolors, Drawings and Writings by Paul Klee,* New York, Abrams, 1958

"Antwort auf eine Rundfrage an die Künstler: über den Wort der Kritik," *Der Ararat,* Munich, Zweites Sonderheft, 1921, p. 130

"Wege des Naturstudiums," *Staatliches Bauhaus in Weimar 1919-1923,* Munich, Bauhausverlag, 1923, pp. 24-25

*Pädagogisches Skizzenbuch (Bauhausbücher 2),* Munich, Langen, 1925. Translated by Sibyl Peech as *Pedagogical Sketch Book,* New York, Nierendorf Galleries, 1944, and by Sibyl Moholy-Nagy as *Pedagogical Sketchbook,* London, Faber and Faber, 1954

"Kandinsky," *Katalog der Jubiläumsausstellung zum 60. Geburtstag von W. Kandinsky,* Dresden, Galerie Arnold, 1926

"Emil Nolde," *Festschrift für Emil Nolde anlässlich seines 60. Geburtages,* Dresden, Neue Kunst Fides, 1926

"Exakter Versuch im Bereiche der Kunst," *Bauhaus; Zeitschrift für Gestaltung,* Dessau, vol. 2, no. 2-3, 1928, p. 17. Published in part as "Paul Klee Speaks," *Bauhaus 1919-1928,* New York, The Museum of Modern Art, 1938, and in full in Robert Goldwater and Marco Treves, *Artists on Art,* New York, Pantheon, 1945

*Über die moderne Kunst,* Bern, Benteli, 1945. Translated by Paul Findlay as *Paul Klee: On Modern Art,* London, Faber and Faber, 1947

Eight poems in Carola Giedion-Welcker, ed., *Poètes à l'écart,* Bern, Benteli, 1945, pp. 105-110

Klee Gesellschaft, ed., *Paul Klee, 1. Teil: Dokumente und Bilder aus den Jahren 1896-1930,* Bern, Benteli, 1949. Translated by Ralph Manheim as *Paul Klee: Documents and Pictures from 1896-1930, Part I,* Bern, Benteli, 1951

Jürg Spiller, ed., *Das Bildnerischen Denken,* Basel and Stuttgart, Schwabe, 1956. Translated by Ralph Manheim as *Paul Klee, the thinking eye: The Notebooks of Paul Klee,* London, Lund Humphries, and New York, Wittenborn, 1961

Felix Klee, ed., *Tagebücher von Paul Klee, 1898-1918,* Cologne, M. DuMont Schauberg, 157. Translated by Max Knight, Pierre B. Schneider and R. Y. Zachary as *The Diaries of Paul Klee, 1898-1918,* Berkeley and Los Angeles, University of California Press, 1964

Felix Klee, ed., *Gedichte,* Zurich, Die Arche, 1960

Felix Klee, ed., *Paul Klee: Leben und Werk in Dokumenten,* Zürich, Diogenes, 1960. Translated by Richard and Clara Winston as *Paul Klee: His Life and Work in Documents,* New York, Braziller, 1962

**Monographs**

The standard work is *Paul Klee* by Will Grohmann, published in German, French, English and Italian editions, 1954. It includes a complete bibliography compiled by Hannah Muller-Applebaum of The Museum of Modern Art, New York. This bibliography has been considerably augmented by Bernard Karpel in Jürg Spiller, ed., *Unendliche Naturgeschichte,* Basel, Schwabe, 1970; translated by Heinz Norden as *Paul Klee: Notebooks Volume 2: The Nature of Nature,* New York, Wittenborn, 1973

Merle Armitage, ed., *5 Essays on Klee,* New York, Duell, Sloan & Pearce, 1950. Essays by Merle Armitage, Howard Devree, Clement Greenberg, Nancy Wilson Ross and James Johnson Sweeney

Berggruen et Cie., Paris, 1952-1971. Six volumes published in conjunction with Klee exhibitions. I: *Paul Klee. Gravures,* 1952. II: *Paul Klee. Aquarelles et dessins,* 1953, introduction by Will Grohmann. III: *L'Univers de Klee,* 1955, introduction by Jacques Prévert. IV: *Klee & Kandinsky: une confrontation,* 1959, introduction by Pierre Volboudt. V: *Klee lui-même,* 1961, introduction by Claude Roy. VI: *Paul Klee. les années 20,* 1971

Rudolf Bernoulli, *Mein Weg zu Klee: Randbemerkungen zu einer Ausstellung seines graphischen Werks in der Eidg. graphischen Sammlung in Zürich, 1940,* Bern, Benteli, 1940

Hans Bloesch and Georg Schmidt, *Paul Klee: Reden zu seinem Todestag, 20. Juni 1940,* Bern, Benteli, 1940

Douglas Cooper, *Paul Klee,* Harmondsworth and Middlesex, Penguin Books, 1949

Pierre Courthion, *Klee,* Paris, Hazan, 1953

René Crevel, *Paul Klee,* Paris, Gallimard, 1930

Andrew Forge, *Klee (1879-1940),* London, Faber and Faber, 1954

Christian Geelhaar, *Paul Klee und das Bauhaus,* Cologne, M. DuMont Schauberg, 1972. Translated as *Paul Klee and the Bauhaus,* Greenwich, Conn., New York Graphic Society, 1973

Hans-Frederick Geist, *Paul Klee,* Hamburg, Hauswedell, 1948

Carola Giedion-Welcker, *Paul Klee,* New York, Viking, 1952

Carola Giedion-Welcker, *Paul Klee in Selbstzeugnissen und Bilddokumenten,* Reinbeck bei Hamburg, Rowohlt, 1961

Jürgen Glaesemer, *Paul Klee Handzeichnungen I, Kindheit bis 1920,* Bern, Kunstmuseum Bern, 1973

Jürgen Glaesemer, *Paul Klee Die farbigen Werke im Kunstmuseum Bern: Katalog der Gemälde, farbigen Blätter, Hinterglasbilder und Plastiken,* Bern, Kornfeld, 1976

Will Grohmann, *Paul Klee,* Paris, Cahiers d'Art, 1929

Will Grohmann, *Handzeichnung 1921-1930,* Berlin, Müller & Kiepenheuer, 1934. Translated by Mimi Catlin and Margit von Ternes as *The Drawings of Paul Klee,* New York, Curt Valentin, 1944

Will Grohmann, *Paul Klee,* Stuttgart, Kohlhammer, 1954; Paris, Flinker, 1954; Florence, Sansoni, 1954; New York, Abrams, 1954

Will Grohmann, *Paul Klee: Handzeichnungen,* Cologne, M. DuMont Schauberg, 1959. Translated by Norbert Guterman as *Paul Klee: Drawings,* New York, Abrams, and London, Thames and Hudson, 1960

Will Grohmann, *Der Maler Paul Klee,* Cologne, M. DuMont Schauberg, c. 1966. Translated by Norbert Guterman as *Paul Klee,* New York, Abrams, c. 1967

Ludwig Grote, ed., *Erinnerungen an Paul Klee,* Munich, Prestel, 1959

Werner Haftmann, *Paul Klee: Wege bildnerischen Denkens,* Munich, Prestel, 1950. Translated as *The Mind and Work of Paul Klee,* New York, Praeger, 1954

Werner Haftmann, ed., *Im Zwischenreich: Aquarelle und Zeichnungen von Paul Klee,* Cologne, M. DuMont Schauberg, 1957. Translated by Norbert Guterman as *The Inward Vision: Watercolors, Drawings, Writings by Paul Klee,* New York, Abrams, 1958

Wilhelm Hausenstein, *Kairuan, oder eine Geschichte von Maler Klee und von der Kunst dieses Zeitalters,* Munich, Wolff, 1921

# Photographic Credits

Max Huggler, ed., *Paul Klee: Dokumente in Bildern, II, 1930-1940*, Bern, Benteli, 1960. Translated by Marcel Rothlisberger as *Paul Klee, Second Part: Paintings and Drawings 1930-1940*, Bern, Benteli, 1961

Max Huggler, *The Drawings of Paul Klee,* California, Alhambra, 1965

Max Huggler, *Paul Klee: die Malerei als Blick in den Kosmos,* Stuttgart and Frauenfeld, Huber, 1969

Nika Hulton, *An Approach to Paul Klee,* London, Phoenix House, 1956

J. M. Jordan, *Paul Klee and Cubism, 1912-1926,* unpublished Ph.D. dissertation, Institute of Fine Arts, New York University, February 1974

Daniel-Henry Kahnweiler, *Klee,* Paris, Braun, and New York, Herrmann, 1950

Eberhard W. Kornfeld, *Verzeichnis des Graphischen Werkes von Paul Klee,* Bern, Kornfeld und Klipstein, 1963

Norbert Lynton, *Klee,* London, Hamlyn, 1964

Thomas M. Messer, *Paul Klee Exhibition at the Guggenheim Museum: A Post Scriptum,* New York, The Solomon R. Guggenheim Museum, 1968

Karl Nierendorf, ed., *Paul Klee, Paintings, Watercolors, 1913-1939,* New York, Oxford University Press, 1941

Nello Ponente, *Klee: Biographical and Critical Study,* Geneva and Lausanne, Skira, 1960

Herbert Read, *Klee (1879-1940),* New York and London, Pitman, 1949

Hans Konrad Roethel, *Paul Klee,* Weisbaden, Vollmer, 1955

Hans Konrad Roethel, *Paul Klee in München,* Bern, Stämpfli, 1971

Gaultieri di San Lazzaro, *Klee: A Study of his Life and Work,* New York, Praeger, and London, Thames and Hudson, 1957. Translated by Stuart Hood.

Georg Schmidt, *Paul Klee: Engel bringt das Gewünschte,* Baden-Baden, Klein, 1953. Translated by T. M. Gang, as *Paul Klee: Angel Fulfilling Wishes,* Stuttgart, Klein, 1954

James Thrall Soby, *The Prints of Paul Klee,* New York, Curt Valentin, 1945

Der Sturm, *Paul Klee (Sturm Bilderbücher III),* Berlin, Der Sturm, 1918

Hermann von Wedderkop, *Paul Klee,* Leipzig, Klinkhardt und Biermann, 1920

Leopold Zahn, *Paul Klee: Leben, Werk, Geist,* Potsdam, Kiepenheuer, 1920

Leopold Zahn, *Paul Klee: Im Lande Edelstein,* Baden-Baden, Klein, 1953. Translated as *Paul Klee: In the Land called Precious Stone,* Baden-Baden, Klein, 1953

## Special Issues of Periodicals

*Bauhaus; Zeitschrift für Gestaltung,* Dessau, December 1931. Wassily Kandinsky, ed., texts by Will Grohmann, Ludwig Grote and Christof Hertel

"Hommage à Paul Klee," *XXe Siècle,* Paris, no. 4, December 1938. Texts by Pierre Courthion and Herbert Read

*Cahiers d'Art,* Paris, vol. 20-21, 1945-46, pp. 9-74. Articles by Georges Bataille, Joe Bousquet, Georges Duthuit, Valentine Hugo, Pierre Mabille, Tristan Tzara, Roger Vitrac, Christian Zervos; poems by René Char and Jacques Prévert

*Du,* Zürich, Jahrg. 8, no. 10, October 1948, pp. 6-76. Articles by Rolf Bürgi, Marguerite Frey-Surbek, Camilla Halter, Max Huggler, Felix Klee, Arnold Kübler, René Thiessing, Walter Uberwasser and Alexander Zschokke; excerpts from Klee's writings selected by Carola Giedion-Welcker

All black and white photographs and ektachromes were made by Robert E. Mates, New York, with Mary Donlon, Paul Katz or Susan Lazarus.

EXHIBITION 77/4
6000 copies of this catalogue
designed by Malcolm Grear Designers,
typeset by Dumar Typesetting,
have been printed by Eastern Press, Inc.
in June 1977 for the Trustees of
The Solomon R. Guggenheim Foundation
on the occasion of the exhibition
Klee at the Guggenheim Museum.
Second printing of 8000 copies
April 1981